CONTENTS

PREFACE 5

INTRODUCTION 6

BIOGRAPHY 8

SICKERT'S HOMES & STUDIOS 9

Richard Shone SICKERT IN THE TATE 10

Penelope Curtis CATALOGUE

1: Sickert and London 15

2: Dieppe 27

3: Venice 34

4: Bath, Brighton and late work 38

BIBLIOGRAPHY 48

4

W R SICKERT

DRAWINGS AND PAINTINGS 1890 – 1942

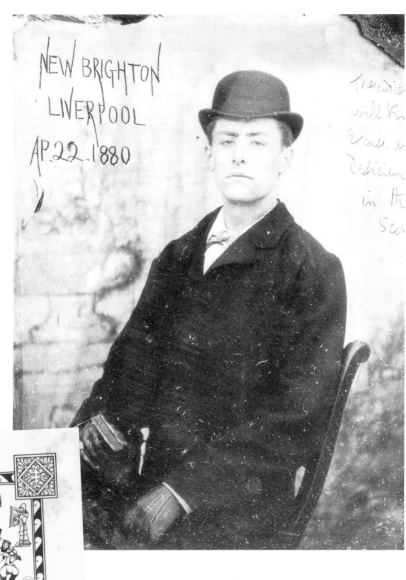

ISBN 1-85437-008-1

Published by order of the Trustees 1989 for
the collection display,
21 March 1989 – 4 February 1990.

Extracts from transcripts of broadcast
interviews by kind permission of the BBC
Extracts from Sickert's letters in the Tate
Archives published with the kind
permission of Gwen Ffrangcon-Davies and
Henry Lessore
Sickert copyright: Henry Lessore
Extracts from Quentin Bell's unpublished
memoirs, previously published by kind
permission of the Scolar Press for the
exhibition *High Steppers*, Scottish National
Gallery of Modern Art, 1982

Published by Tate Gallery Liverpool,
Albert Dock, Liverpool L3 4BB
Designed by Jeremy Greenwood,
Liverpool
Colour origination by Axis Photo Litho,
Runcorn
Printed in Great Britain by Cox Rockliff
Limited, Liverpool

The works from the Walker Art Gallery are
loaned by kind permission of the Trustees
of the National Museums and Galleries on
Merseyside

Photo credits
Tate Gallery Photographic Department
for all works in Tate collection
Ashmolean Museum, Oxford p 23, 24, 25
British Library p 42, 43
Ferens Art Gallery: Hull City Museums and
Art Galleries p 42
Islington Public Libraries Collection p 7
Manchester City Art Galleries p 29
John Mills Photography Ltd p 47
National Museums and Galleries on
Merseyside (Walker Art Gallery,
Liverpool) p 35, 42
Phaidon Press p 44
The Witt Library, Courtauld Institute of
Art p 24, 25, 41

Front cover: catalogue 23. *L'Armoire à Glace*
1924
Frontispiece: photograph from the
collection of Barbara Bagenal, Tate
Archives, apparently representing Sickert
on the occasion of his appearance in *Henry V*
at the Royal Amphitheatre, Liverpool, in
April 1880.
Back cover: catalogue 13. *The New Bedford*
1915–16

PREFACE

The Tate Gallery is fortunate to have within its collections particularly fine groups of work by a number of artists. Last year we began our programme in Liverpool with a display of paintings by Mark Rothko. That presentation sought to place the works owned by the Tate Gallery within the context of Rothko's development as a whole. Now we are showing Sickert in a similar manner, augmenting our own collection with a number of most generous loans.

The Tate Gallery collection of paintings and drawings by Sickert is unusually strong – with forty five works spanning the period from 1890 to the end of the artist's life. It covers most of the themes and places that Sickert painted though inevitably no one subject is represented by more than a few works.

While very much a man of his time – enthralled by the popular life and topical events of the period – Sickert has also continued to occupy a position of unusual interest to artists of succeeding generations. Part of this interest lies in Sickert's artistic process; working from photographs and newspapers, squaring up the sketches to prepare for the paintings. The Tate has few of Sickert's drawings, but the Walker Art Gallery's generous commitment of drawings and prints from its extensive Sickert collection helps to make this exposition of 'process' a principal feature of the exhibition.

The Sickert display will link with two other exhibitions in the programme of the Tate Gallery, Liverpool. Exhibitions devoted to Edgar Degas and Francis Bacon overlap and follow this presentation, establishing a line of artists linked by common practices and parallel concerns. Sickert maintained, 'There is no such thing as modern art. There is no such thing as ancient art … History is one unbroken stream. If we know Degas, Degas knew Ingres, and so on, *ad infinitum*'.

We are grateful to the lenders who have been prepared to commit their works to a display of long duration, and especially to the Trustees of the National Museums and Galleries on Merseyside, without whom it would have been the poorer.

Nicholas Serota
Director
Tate Gallery

Richard Francis
Curator
Tate Gallery Liverpool

INTRODUCTION

Penelope Curtis

Although Sickert played an important role in several of the most significant artists' groups formed in Britain in the early part of this century, he resists categorisation, standing resolutely apart. He was both very much of his time and yet outside it. He was an exact contemporary of Seurat, and slightly older than artists such as Vuillard and Bonnard, with whom he has a certain amount in common. It is quite conceivable that Sickert would have been successfully absorbed into the French school had he stayed in France. Instead, he returned to England, where he painted pictures that were probably deliberately English in order to appeal to the French market. The Parisians were aware of his quintessentially 'English' Camden studies two years before the English public.

Sickert painted hundreds of pictures, working on several at any one time. His many drawings, which until the early 20s served as the documentary basis to his painting, enabled him to pick up a subject some years after he had originally drawn it. There is no *catalogue raisonné* of Sickert's work. The most complete inventory to date, that compiled by Dr Wendy Baron, lists 451 paintings, many of which have several versions.

It is difficult to evaluate to what extent, and how well, Sickert was able to live from his work. His first two marriages, especially that to Ellen Cobden, undoubtedly eased the strain. After this marriage ended Sickert went to Dieppe, as if fleeing from London. When he returned there, he sold his collection of Whistler etchings to pay for the move. When he was under particular financial pressure, Sickert wrote articles on art and taught. The frequency of these activities is perhaps a measure of how often he was hard up; on the other hand it is obvious that he enjoyed writing, and, most especially, teaching. There seems to be no regular pattern to Sickert's revenue; at any one time he might sell paintings at both high and low prices. His paintings of Venice, his coloured drawings of Dieppe, and his later 'Echoes' sold well at the dealers, and Sickert appears to have been happy to cater for these outlets. Other paintings lay stacked in his studios for years, with Sickert making either no attempt, or only quirky entrepreneurial attempts to sell them.

The paintings and themes which are most readily associated with Sickert – music halls, Venice, dingy London interiors inhabited by anonymous 'tenants', the 'psycho-dramas' of Camden Town – all date to the pre-war period. The fact that they are also painted in thick, creamy, predominantly earthy colours means that Sickert is frequently seen in this light. The fact that, for Sickert, his technical breakthrough came in the war years, after which he painted increasingly dry, bright, even acidic pictures, is often overlooked. Concurrently he moved away from the immediate observation of the motif, working in a manner that increasingly distanced him from 'the life', and depended instead on two-dimensional records. His development of the 'series' is reminiscent of Monet's development of one motif, and it is indeed possible that Sickert saw Monet's exhibition of his 'Cathedral' series in 1895.

Sickert's procedure, whether working from drawings or photographs, always involved several stages. He attached a great deal of importance to what he called the 'cooking' side of painting. Clifford Ellis, who knew him in his last years in Bath, attempted to explain the fascination of Sickert's painting:

I think that of some of the things which are so difficult to explain about him this may explain one. The extraordinary lengths he went to in the preparation of painting – the drawings and the drawings and drawings, the photographs and all the other things that he accumulated. Then, taking a deep breath and doing something quite different in the actual painting. Very frequently there was a divorce between the two, that this 'standing to attention', as it were, whether for the sake of his father or whatever the kind of conscience was, was one thing and painting was sometimes another. This explains the very good and the very bad ones. But where the two things clicked, where all the preparation and the painting were all one, it came off as it did with Degas.

This display is based on the Tate collection, and works on loan are listed in the catalogue under the Tate work to which they relate. Three loan paintings supplement the Tate holding, and occupy independent listings. Two are 'Echoes' and make up for a significant gap in the collection. The painting of Gwen Ffrangcon-Davies replaces the Tate painting of her as Isabella of France which is too fragile to travel. The only other Tate work not to come to Liverpool, for the same reason, is the pastel 'Mrs Barrett'. All works are from the Tate collection unless indicated to the contrary. Measurements are given in millimetres; height then width. For fuller catalogue details of these works, the reader is referred to the relevant Tate Gallery catalogues. The standard work of reference is Dr Wendy Baron's *Sickert* (1973), which post-dates the majority of the Tate entries, and is invaluable for any student of Sickert.

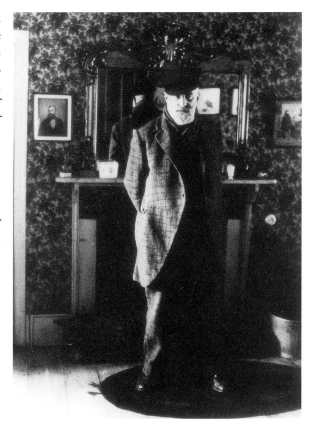

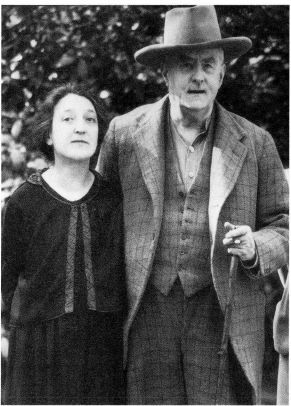

Right above: Richard Sickert at St Peter's-in-Thanet c.1934.
(Islington Public Libraries Collection)
Right below: Sickert and his wife Thérèse Lessore, late 1930s.
(Islington Public Libraries Collection)

1860
31 May Born in Munich, son of Oswald Adalbert Sickert, a painter and illustrator of Danish descent, and of Nelly Sickert, the illegitimate daughter of the Astronomer Royal, Richard Sheepshanks.
1868
Family moved to England.
c.1879-81
Toured the provinces as an actor.
1881
Studied briefly at the Slade School of Art; by the end of the year attached himself to Whistler as apprentice and etching assistant.
1883
Sickert escorted Whistler's painting 'Portrait of the Artist's Mother' to the Paris Salon; met Degas for the first time.
1884
First exhibited picture, Royal Society of British Artists.
1885
Married Ellen Cobden, daughter of the politician Richard Cobden; they stayed in Dieppe at the close of their honeymoon.
1887
Showed with avant-garde exhibiting society Les XX in Brussels.
1887-9
Concentrated on painting London music halls.
1888
Joined the New English Art Club (NEAC).
1889
Visited Universal Exhibition in Paris with Degas; bought Degas'

painting 'Répétition'.
1890-95
Contributed illustrations and portrait drawings and caricatures to periodicals.
1895
First visit to Venice, which lasted up to a year.
1896
Separation from Ellen, ending in divorce 1899. Financial difficulties led to his founding a school in Victoria Street with Florence Pash, which lasted two years.
1897
Definitive breakdown in relations with Whistler.
1898
Winter, left London for Dieppe, and stayed there until 1905.
1900 & 1901
Visits to Venice.
1903-4
Visit to Venice.
1904
Summer, returned to Dieppe. Large show at Bernheim-Jeune Gallery in Paris, most works on loan from private collectors.
1905
To London; but continued to spend summers in Dieppe until outbreak of war.
1906
Rejoined NEAC after a lapse of over eight years; was a member until 1917. Began painting music halls again, and furthered this interest on an autumn trip to Paris.
1907
Back to Paris to supervise important exhibition at Bernheim-Jeune. At this, and subsequent

show of 1909, prices low, but sales to celebrities.
1907
Spring, Fitzroy Street group began as a semi-formal grouping of artists meeting regularly at Sickert's. Most of the new artists' exhibiting societies formed in the years up to the war sprang from this group.
1908
Began teaching at the Westminster Technical Institute which he continued until 1918.
1910
Founded Rowlandson House school; lasted until outbreak of war.
1911
Married Christine Angus.
1911-13
Camden Town Group formally constituted, and at their first exhibition in 1911 the first of his 'Camden Town Murder' paintings – 'Summer Afternoon' – was exhibited in Britain.
1911-14
Sickert exhibiting extensively in London.
1914-18
Confined to England. Spent first winter in London, visited Chagford in Devon and Brighton in 1915, and spent much of 1916-19 in Bath. Continued to teach at Westminster Technical Institute and give private classes. Wrote articles for The Burlington Magazine, including one on Degas in November 1917, inspired by recent death of Degas, whose influence is also visible in

contemporary paintings. Around 1914 Director of the Carfax Gallery guaranteed Sickert a fixed income of £200 a year plus sales, but Sickert broke the contract in 1916.

1919

Gave up teaching, and settled in Envermeu outside Dieppe with Christine.

1920

Christine died. Sickert took rooms in Dieppe and lived there until 1922.

1920

Painted music halls of Shoreditch.

1923

W H Stephenson became a staunch supporter, and Sickert wrote a series of articles for his newspaper the *Southport Visiter*. Sickert also contributed pieces to the *Daily Telegraph* and the *Burlington*, and gave lectures around the country.

1924

Elected as Associate Member of the Royal Academy, and adopted his second name in place of his first ie Richard Sickert in place of Walter Sickert.

1925

Briefly involved with teaching weekly class in Manchester. Loan retrospective at the NEAC.

1926

Married the painter Thérèse Lessore, whose work he had already much admired. They spent some time in Margate, Newbury and Brighton. Taught at Royal Academy Schools.

1927

Settled in Islington. Opened last of private schools at 1 Highbury Place. In Islington frequented Sadler's Wells theatre, making friends with several famous actors and actresses.

1929

Last of Sickert's prints published, marking the end of this line of activity some years after he had already ceased to draw.

1932

The Louvre bought 'Hamlet', an 'Echo' of c.1930 after John Gilbert.

1934

Settled near Margate, at St Peter's-in-Thanet, and taught at Thanet School of Art. Elected to full membership of the Royal Academy, resigned the following year in support of Epstein's British Medical Association sculpture. Public subscription appeal in his favour raised £2,500.

1938

Moved to Bathampton outside Bath. Taught at Bath School of Art until war broke out. Exhibition of his work in Chicago and Pittsburgh.

1942

22 January, died. National Gallery presented exhibition of his work.

Locations of Sickert's homes and studios in London, in chronological order from 1891

Homes
Broadhurst Gardens, NW6
Fitzroy Street, W1
Harrington Square, NW1
Gloucester Crescent, NW1
Kildare Gardens, W2
Quadrant Road, N1
Barnsbury Park, N1

Studios
Glebe Place, SW3
The Vale, SW3
Cheyne Walk, SW3
Robert Street, NW1
Embankment Gardens, SW3
Fitzroy Street, W1
Mornington Crescent, NW1
Angustus Street, NW1
Grosvenor Road, SW
Brecknock Road, N7
Red Lion Square, WC1
Warren Street, W1
Fitzroy Street, W1
Noel Street, N1
Camden Road, NW1
Whitcher Place, NW1

Schools – Studios
Hampstead Road, NW1
Granby Street, NW1
Highbury Place, N1

SICKERT IN THE TATE

Richard Shone

In a television interview last year, David Hockney twice mentioned the pervasive influence of Sickert's work in the art schools in the 1950s.[1] It was something he wished to avoid – low-toned, domestic painting, small in scale, very English and, as Hockney indicated, not to his purpose at that time. His remarks contain a pinch of truth wrapped in a tissue of misapprehensions. The type of Sickert to which Hockney alluded is characteristic of only certain phases in Sickert's long career. Specifically domestic subject matter is only one among many kinds of subject Sickert was drawn to. His teaching was atypical of that found in the majority of schools and his posthumous influence was relayed through the pedagogy of imitative, minor talents. It was the charming but debased work of Sickert's 'disciples' that would have been familiar to Hockney. As for Sickert's Englishness, we know that not only was he one of the most cosmopolitan figures of his age, but that he was of Danish, German and Irish extraction. Just how 'foreign' he can seem is visible in such paintings as 'La Hollandaise' or 'A Marengo'; how rebarbative he can appear, with his sleeves rolled up, in contrast to the armchair politeness of his contemporaries such as Steer or Nicholson or Tonks. The Englishness of some of his subject matter has a racy, appreciative quality that is almost caricature, an 'outsider's' local colour. Nothing can be taken for granted in Sickert; all is illusion, construct, double-take, the result, as he wrote, of his 'leisurely, exhilarated contemplation'.[2] Several recent exhibitions and studies have made clear Sickert's variety, his reach back into the European tradition, his stretch forwards into the art of our own period.

Among his generation, David Hockney would by no means have been alone in thinking Sickert the bane of British painting. His 'influence' tolled through the art schools in innumerable ways. But it was chiefly the earlier Sickert, the painter of Dieppe, Venice and Camden Town, that wearied later generations. His work of the 1920s and 30s was still to be rediscovered. Yet curiously, and ironically, Sickert had treated 'subjects' that Hockney, for example,

was to make his own. In the Tate Gallery's collection of Sickert's work we can see double-portraits, unorthodox sexual frankness, photo-based scenes of daily life and people, images of marital stress ('The Little Tea Party'), revealing self-portraits and a consistent interest in popular culture, a nose for social detail. All of these Hockney either embraces or touches on in many of his early works. And Hockney is not alone in this; there are affinities between Sickert and associates of Hockney's such as R B Kitaj and Peter Blake, as well as Brett Whiteley whose 'Christie Murders' series of 1964 echoes Sickert's 'Camden Town Murder' variations of 1908-10.

One charge has to be faced, however, and that is Sickert's gloom. Yes, people say, a marvellous painter but so gloomy; and the names of Vuillard and Bonnard are marshalled into the conversation. When so many of Sickert's contemporaries were bursting into the liberating primaries of Post-Impressionism and Fauvism, Sickert appears almost perverse in his inscrutable, dark extremism. The one pre-1914 movement in which colour can be as subterranean as Sickert's was the early Cubism of Picasso and Braque, work which Sickert heartily disliked. His gloom results from a definite philosophical programme rather than from a reflection of his own stoic cheerfulness of temperament. A construct of visual thought impelled his exploration of low tone, murky colour and reluctant highlights. It parallels several of his contemporaries in literature, linking Sickert to the suggestive discretions of some of the Symbolist poets as well as the naturalistic gloom of scenes in the fiction of Zola, Gissing, Moore, Bennett and the early Somerset Maugham. In the span of Sickert's work over sixty years, we find a consistent awareness of contemporary thought and atmosphere.

The gloom began to falter after Sickert's seminal return to London from Dieppe in 1905. It was by no means abandoned but we find a more varied web of stronger colours beneath the habitual dress of umbers, ochres, olive green and black. Some astonishing lights go up in his oppressive theatre of activities. That they had always been a possibility can be seen in

the garrulous red of 'Minnie Cunningham' or in the Whistlerian fireworks of the 'Interior of St Mark's'. In London, Sickert began to sort through the shadows and discover colour so that a necessary heightening of tone in the lighter areas introduces some brilliant passages. The declamatory head of 'Harold Gilman' exemplifies this, with a corresponding diversity of brushmarks as though the very exuberance of novel colour demanded fresh gestures of the hand. Over the following years, the gloom was gradually dispelled though there were occasional war-time returns.

In Bath in 1917 and Dieppe in 1919-21 Sickert developed a different range of colour to suit simultaneous changes in mood and subject. He refused to flare and only rarely do we find uncompromised stretches of bright, unmixed hues. That was to come later. But in Dieppe he certainly raised the temperature with acid greens, butter yellow and salmon pinks, reflecting the brittle chic of gamblers in the Casino, people now at leisure, rather than at war. Gaining confidence in the late 1920s, Sickert became, in the 30s, an intrepid colourist. It is true that he retained something of his earlier harmonies. To let them go would have been to deny his history. More often, though, he is broadly sumptuous, revelling in colour for its own delight, taking a leaf from the great Venetians who he admired. Never facile, glossy or unnecessarily various, his colour is often chalky in the higher registers, and warm in the darker areas where Sickert maintains the subtlest obliquities in a final freedom from modelling.

The range of Sickert's subject matter is conspicuously varied. Early on he developed a method of treating subjects in series. He would fully explore aspects of a motif from large numbers of studies to highly finished drawings and a cluster of related paintings; frequently the subject would also be etched. He learnt his lessons from Degas with all the zeal of a neophyte; Monet and possibly Sisley lie behind the groups of Venetian and Dieppe motifs painted at differing times of day. They move from sparkling morning light to the crepuscular visions of Dieppe at dusk (Catalogue 18), contrasting the looming cliff of the Poissonnerie with fleeing purple cloud. In his later years, the drawn studies become less frequent as the photograph took over as a source of information.

But the number of new subjects increased as older more familiar ones were dropped from the repertory. Music hall, at its last gasp in the 1920s, was replaced by scenes from the legitimate stage – of Peggy Ashcroft, John Gielgud, Paul Robeson and Gwen Ffrangcon-Davies in usually climatic or tragic moments from Shakespeare. More wry theatrical moments characterise Sickert's depiction of his own daily and domestic life. Famous faces appear from the worlds of politics, business, the stage and screen, of Royalty and Society. Though the Tiller Girls make a high-stepping, late appearance, we are more likely to see the eminent faces familiar from the concert hall – Joe Haynes, chairman at Gatti's, stands down for Sir Thomas Beecham, and Ada Lundberg, knocking them at the Marylebone, for the great mezzo-soprano Conchita Supervia. Newspaper photographs put them all within Sickert's grasp. Late 'genre' and landscapes reflect the rapid changes of fashion and the look of day-to-day life. Cars in the streets of Bath take the place of broughams; breezy girls in shorts succeed the cockney costergirls in straw hat and shawl. Sickert's inclusive methods of selection and transference ensured a continually lively response to his immediate surroundings. At the same time, in his series of 'Echoes', a modern sensibility transfigures the mid-Victorian age.

A consideration of the subject matter of the Tate Gallery's Sickerts is revealing, as much as for what is there as for what is absent. Only about a third of the works were actually purchased by the Gallery; two-thirds were gifts, often through the Contemporary Art Society, or were bequests, particularly the six paintings bequeathed in 1940 by the widow of Lord Henry Cavendish-Bentinck. Thus the representation has relied on the taste of committees and the accidents of private collecting. With English partiality, a dozen are specific portraits or full-length figures. Until the recent purchase of 'La Hollandaise', the frank, even brutal aspect of Sickert's work was invisible; there are no naked two-figure paintings, nothing from the 'Camden Town Murder' series, no bedroom scenes of marital stress. There are, however, two representations of married gloom – 'Ennui' and 'The Little Tea Party' – and even a third if we take seriously the jocular title of 'Off to the Pub'. It has to be remembered that Sickert's pre-1914 subject

matter startled and shocked some of his more fastidious contemporaries. The painter Sir William Blake Richmond wrote to Robert Ross in 1911 of Sickert's 'drawings, or rather scribbles and for the most part indecent at The Carfax. They are worse than the P.I.'s, I went to-day to see them, because being quite bad as Art and being 'Dirty' they are demoralizing and ought to come under [notice of] the Police.'[3] Sickert's colleague, Fred Brown, Professor of Painting at the Slade School, felt obliged to end their friendship on account of the sordid nature of Sickert's work. Obviously such paintings raised eyebrows when seen alongside the decorous gentilities of much contemporary English painting. Even before this, Sickert's pictures of the music-hall stage had been regarded by some with disdain. The relative novelty of his method of painting was seen as inextricable from the coarseness of his subject matter. Lack of 'finish' was somehow 'suggestive' and, at the same time, socially below the belt.

In the Tate Gallery only one work, 'Minnie Cunningham', stands in for the galaxy of Sickert's first great period of theatre paintings. Luckily, drawings from the Walker Art Gallery, on-the-spot studies, supplement the painting, with images of the Sisters Lloyd and of Bessie Bellwood, the serio-comic famous for leaving any hecklers in her audience 'gasping, dazed and speechless'. However, Minnie Cunningham's song 'I'm an old hand at love, though young in years', contains all the innuendo typical of the genre, the singer's scarlet hat and dress and demure expression conforming to what Marie Lloyd termed 'romping schoolgirl songs'. The other theatre painting in the collection, 'The New Bedford', belongs to a later phase. The Old Bedford Theatre, Camden Town, was burnt down in 1899 and Sickert has left us innumerable records of its stage and clientele (a notable version being the one in the Walker Art Gallery). The new theatre rose splendidly on the ashes of the old, opulent with gilded caryatids, cupids and masks, red velvet and blue plush. Sickert's earlier versions of enraptured cockney heads in the gods give way to the posh hats and feathers of the stalls, dwarfed by true music-hall Baroque. Gaslit chiaroscuro from the 1890s is here replaced by the glittering democracy of electric light. Sickert's topographical exactitude, learnt in Venice and Dieppe, served him well when transcribing the Bedford whose soaring extravagance comes uncomfortably close to the 'galleried' interior of St Mark's (Catalogue 24).

Between 'La Hollandaise' of c.1906 and 'Ennui' of c.1914, there is no typical Camden Town interior-with-figures in the Tate (save the marginal 'Off to the Pub') to show Sickert's rapid progress in a phase marked by the influence of his younger friend Spencer Gore. The simian flash of La Hollandaise, one breast defined, the other slung into shadow, her figure suggesting movement, is one of the most uncompromising nudes painted in England. Insolent and professional, she allowed Sickert access to a vein of explicit portrayal worthy of Maupassant, and as concise in scale. Six years later, the lightening of Sickert's palette and the extended variety of his handling of paint are best seen in the head of Harold Gilman. But the portrait of another painter, Jacques-Emile Blanche, foreshadows this release. The Frenchman's face is painted in a spotted range of green, cream and rose madder, solidity realised through disintegration, and strikingly offset by the suave darkness of top hat and coat. Sickert's portrait of his peppery, anglophile friend is a just characterisation. Conversational intimacy balances slight withdrawal, emphasised by Blanche's outdoor clothes as he sits in Sickert's Rowlandson House studio; here is the painter Elstir from 'A La Recherche', partly modelled by Proust on the ubiquitous Blanche. Sickert scorned the rôle of professional portraitist and rarely accepted commissions, doing so only when poverty was acute. But in the informal portraits of Blanche and Gilman, and in the superbly disobliging study of George Moore (Catalogue 2), he proved himself notably alert to the fleeting and the permanent in his sitters' physiognomies. Both characteristics are central to all Sickert's work.

'Ennui', the most celebrated Sickert in the Tate Gallery, is always slightly disappointing, especially when compared to the smaller version in the Ashmolean, Oxford. Is it the overall smoothness of surface, 'its self-conscious mechanical quality', as Wendy Baron suggests,[4] its almost too perfect ordering of its components? Sickert's detachment on so large a scale and the overwhelming mood of estrangement ultimately sterilise one's response. But it is an undeniably memorable statement. Sickert here summarises his new-found method of accumulating patches of

clean pigment, layer upon layer, to cover a *camaieu* ground of two colours, indicative of light and dark throughout the composition. At this time, he preferred pale pink and pale blue for the *camaieu*. Over the years, these changed (in 'The Front at Hove', for example, prussian blue and olive green are used on the white canvas) and were sometimes increased to four. The underpainting became more visibly avowed in the following decades, as did the squaring-up process by which a drawing or photograph was transferred to canvas (the two-inch squares can clearly be seen, for example, in the three Martin portraits). At the time of 'Ennui' Sickert's colour range was still broad throughout the picture – from the bright matchbox on the table to the variegated stuffed-birds and the picture on the wall (which has all the look of a Sickert of the 1930s, and remains tantalisingly unidentified).

Between the wars Sickert came to hold a curious position in English art. His early reputation in France had dwindled almost to nothing[5] and his work seemed unexportable to the United States (where his reputation is even now precarious). Though revered and imitated in England, few of the major figures in English art came under his influence. In the later 1930s, however, the Euston Road painters rallied to his example, though they tended to ignore his recent work in favour of the Camden Town, Venice and Dieppe periods. Pasmore's 'Jewish Model', Graham Bell's 'Café' and Coldstream's 'Studio' are all unimaginable without Sickert's brooding presence. Claude Rogers remembered the impact on Coldstream himself of Sickert's Leicester Galleries retrospective in 1929, prompting both artists to paint from careful studies and drawings. But in another sense Sickert was left high and dry, a compelling figure valuable for his past and for his European connections, as much as for the current didacticism of his lectures on painting and drawing. The work he showed in the 1930s was fitfully received. It displeased many old admirers such as Clive Bell, who found the 'Echoes' 'ridiculously feeble',[6] and D S MacColl who thought the photo-based paintings ought 'not to be remembered against him'. Augustus John called him a 'sham'[7] and the young Michael Rothenstein felt the work 'had no core' and lacked conviction.[8]

With hindsight, we have learnt to look again at the extraordinary productions of his old age. As they become better known and re-discovered (for many are still untraced), they invite closer discrimination. As in all periods of Sickert's work, there are failures and successes. In the best, apart from their intrinsic achievement, we can recognise affinities with art nearer to our own period, demonstrable in the sheer 'look' of the paintings, which cause delight, surprise and re-evaluation. Sickert introduced a number of new subjects, painted on a large scale broadly and confidently and, in his portraits, delivered some of the unforgettable images of modern portraiture. In the series of 'Echoes' he 're-told' in vibrant colour, the anecdotes of Victorian illustrators and in his 'genre' pictures he explores new aspects of contemporary life and his own domestic world. His process of painting became streamlined enough for him to employ assistants (such as Morland Lewis and Mark Oliver); and as his energies deteriorated he relied on his third wife, Thérèse Lessore, to photograph his subjects, and prepare and underpaint his canvas.

That Sickert's late work remained generally unappreciated – and still has its detractors[9] – can be seen from its thin representation in the Tate. There are eight paintings from the last eighteen years of his life of which only two have been purchases – the relatively uncontroversial 'Front at Hove', which was bought two years after it was painted, and 'Miss Earhart's Arrival', only acquired in 1982. The other six were gifts or bequests all made in the 1950s, save for the magnificent 'La Louve', ('Miss Gwen Ffrangcon-Davies as Isabella of France') presented in 1932. One of Sickert's masterly images of royalty ('A Conversation Piece at Aintree') was actually refused by the Tate (after an earlier refusal by Glasgow) as a gift in the late 1930s. There are no 'Echoes' in the collection and no late landscapes of Kent or townscapes of Bath. Happily, there are two 'self-portraits' from a long series - the sly, self-mocking 'Front at Hove', a scene as observable in the same spot today as it was in 1930 – and the oddly titled 'Servant of Abraham' (no such 'subject' exists in the Bible, though Sickert is probably suggesting his sustained vigour and venerable role, more explicitly declared in the companion self-portrait 'Lazarus Breaks his Fast', in a London private collection).

The three Martin portraits constitute an express- 13

ive, interrelated group which combines several hall-marks of Sickert's late style. They are large, partly done from specially taken photographs, domestic, pungent in their conveyance of human presence, a 'crystallisation', as William Plomer wrote, 'of the unguarded and revealing moment'.[10] Even the family's smiles are highly typical. The painted smile was a speciality of Sickert – from the toothful grins of his Camden Town models to the equivocal purr of Edward G. Robinson in 'Jack and Jill' and George V's Jubilee acknowlegment of his cheering public. Here, the Martins smile for Thérèse Lessore's camera. The photographic source is blatant, the process including stray details and half-explained passages of modelling. Forms are subsumed by light; refinements are avoided. The abstraction of the image is insisted on yet, as one should expect from Sickert, humanity is realised through a vividness of pose and expression in all three paintings. How surely Sickert succeeds in making, as he wrote, 'the someone emerge naturally from the already established somewhere'.[11] But he makes no pretence at formal portraiture or of showing us the social éclat of his sitters. If Lady Martin's hands look large and coarse, so be it; if the surroundings (Sickert's St Peter's studio) look threadbare and improvised, they must not be altered.

Such an approach suggests a change in Sickert's conception of the world as well as of his transcription of it. His earlier figures-in-interiors displayed a construct of 'reality' that emphasised narrative and situation. His models peopled an essentially artificial view of life; his studios were transformed into the shuttered playgrounds of marital discord, the sharps and flats of 'getting along together', as seen in 'Ennui' and 'Off to the Pub'. In such photo-based paintings as the Martin group and 'Miss Earhart's Arrival', Sickert includes all the snapshot visual peculiarities that render his images simultaneously banal and mysterious. In this sense, the results are the same. No matter how economically compressed his work became, Sickert's view of life remained essentially unchanged. Early subtleties of handling and scaled niceties of tone will be missed by those who refuse to see Sickert whole. Forty-five years separate 'Minnie Cunningham' from 'Claude Phillip Martin'. Both, in their appropriate ways, commemorate the immediate pleasures of the here and now; and both encapsulate, through Sickert's contrivance, his stoical awareness of the passing of each moment.

NOTES

1. Hockney in interview with Melvyn Bragg, *South Bank Show*, LWT, 30 October 1988.

2. Sickert to Nina Hamnett from Bath 1918, quoted in Wendy Baron, *Sickert*, London, 1973, p.182.

3. Sir William Richmond to Robert Ross, 16 January 1911, quoted in Margery Ross (ed): *Robert Ross. Friend of Friends*, London, 1952, p.196. 'P.I's' refers to the exhibition 'Manet and the Post-Impressionists' at the Grafton Galleries, London, 1910-11. 'Carfax' refers to Sickert's one-man show of drawings at the Carfax Gallery, January 1911.

4. Wendy Baron, *op. cit.*, p.144.

5. The French painter A Dunoyer de Segonzac, in a catalogue preface to an exhibition in Paris of works by Sickert, Smith and Wood, wrote of 'le très grand artiste Walter Sickert qui a travaillé longtemps en France, mais que beaucoup d'artistes de la jeune génération connaissent peu ou ignorent totalement'. (*Trois Peintres Anglais*, Galerie Bing, Paris, 16 June to 7 July 1939).

6. Clive Bell 'Sickert at the National Gallery', *New Statesman and Nation*, 6 September 1941.

7. In Andrew Forge (ed): *William Townsend Journals*, London, 1976, 22 November 1935, p.35.

8. Michael Rothenstein in a review of Sickert's National Gallery retrospective 1941, *World Review*, October 1941.

9. For example Peter Fuller: 'British Art in the 20th century. The later years', *The Burlington Magazine*, April 1987, p.264; Brian Sewell (in numerous publications) and Malcolm Yorke: 'Walter Sickert', *Modern Painters*, No.4, Winter 1988/9, p.103. Yorke writes of 'Idyll' and 'Summer Lightning' (both exhibited in this exhibition) that: 'No amount of textural variety will redeem them from their Victorian sweetness' – a curious remark to make in connection with 'Summer Lightning', a painting of impending molestation or rape.

10. William Plomer: 'Mr Sickert's Exhibition', *The Listener*, 9 March 1938.

11. W R Sickert in *The New Age*, 11 June 1914 (quoted in Osbert Sitwell (ed): *A Free House*, London, 1947, p.330).

1: SICKERT & LONDON

The addresses of Sickert's homes and studios around London are too numerous to list here (see page 9). Two points stand out clearly. Firstly, Sickert saw it as essential that he always had a number of working spaces from which to choose, and a new location from which to draw inspiration. Secondly, a clear geographical divide occurs early in his career when Sickert, on his return to London from Dieppe in 1905, chose not to return to Chelsea but to settle definitively in North London. Thereafter, though he moved frequently, it was always within the areas of Bloomsbury, Camden Town and Islington. Theoretical geographical divides were made much more real during the war years due to the physical difficulty of travelling across London. Sickert's biographer Emmons describes Fitzroy Street in this period as 'worlds apart from Chelsea'.

The writer George Moore, with whom Sickert had passed many evenings in Chelsea in the company of the painters Tonks, Brown and Steer, recalled, 'I do not think I shall forget the sadness of the evenings we spent in 109 Cheyne Walk and in Vale Avenue, sitting together asking ourselves if Sickert would come … But what had become of Sickert? … it was not until a few weeks later that we heard that Sickert had gone to live in Camden Town … Sickert came to visit us, and after one delightful evening … we saw him no more … as there seemed but small hope that he would return to Chelsea, we resumed our old conversations in Cheyne Walk and in Vale Avenue … and we could not yet understand why Sickert needed a studio in Venice, a studio in Paris, a studio in Dieppe, and three or four in London'. In his memoirs the artist Ludovici describes Camden Town in the sixties as 'the neighbourhood selected for residence by professional artists, literary men and actors of limited income. Fitzroy Square and Bloomsbury were reserved for prosperous professionals and business men'. However, many of the large family houses around Fitzroy Square had been sub-divided, providing accommodation for artists and craftsmen, notably those in the furniture trade. Whistler went to Fitzroy Street when, according to Ludovici, he 'was looking for a studio in what he called the classical neighbourhood of Art'. The number of artists resident in Fitzroy Square and Street from the mid nineteenth century bears out Whistler's observation. Sickert was fond of the notion of the artistic tradition of an area; he was proud to take over the studio that Whistler had chosen in 8 Fitzroy Street, and delighted in occupying that of the archetypal Victorian artist, W P Frith at No 15. The tradition continued with Paul Nash and Vanessa Bell and Duncan Grant taking over Sickert's 8 Fitzroy Street studio.

From 1906 Sickert was committed to the Camden Town area of London, both for his studios and his residences. An observer of 1900 described the area as 'Camden Town, which as recently as 1870 had been a residential quarter of wealth and even fashion … had become largely a place of business; among the residents servants were rare and in nearly every house there was a lodger'.

Sickert's preferred London borough in later life – Islington – had undergone similar changes in the profile of its population, and this was very much due to the expansion of the railways. What had been, in the eighteenth century, 'merrie Islington', home to entertainment gardens, dairies and market gardens, became in the nineteenth a building site and brickfield. The railways which had at first taken the middle classes to Islington, later led them further out to newer, more desirable suburbs. They had moved out of Islington by the 1880s and 90s, and by 1902, when Charles Booth published his survey of the number of servants per household in the various London boroughs, Islington was notably far down the list. By the Edwardian period family homes had become boarding houses, offices and warehouses. Most of the areas within Islington, such as Barnsbury, experienced a similar shift. However one should not regard as unique Sickert's fidelity to this area. Canonbury, for instance, was, as early as the 1930s, a recognized haven for academics and artists.

Many friends recall the experience of being taken to see Sickert's various studios by cab. Clive Bell wrote, 15

'he insisted on showing us his "studios" – "my drawing studio" "my etching studio" etc. The operation involved chartering a cab and visiting a series of small rooms in different parts of London'. Helen Lessore remembered seeing the studios in Campden Crescent and Rochester Mews 'in the course of a taxi drive taking me home at night'.

'He'd only just taken the place' she recalled. 'But he was very excited about it because he always got a sort of fresh drive out of a new place and so he loved taking new studios'. Sickert liked to assemble assorted knick-knacks in these new rooms, which were dominated by 'vast pieces of furniture, Victorian sideboards'. It was not only the new location that inspired Sickert; he required further stimulus from the arrangement of any one room. 'He lived in this sort of chaos of a studio which was something like a kaleidoscope; everytime you went he'd seemed to have shaken the whole studio into a new pattern; and it was always in an awful state of untidiness, he needed that kind of chaos around him'.

Cicely Hey, who described herself as 'the last occupant of the iron bedstead', often modelled for Sickert in these rooms. 'You could never get in without a telegram and a special knock... he wouldn't see anybody during his working hours. He painted behind his locked doors alone'.

1. *Minnie Cunningham at the Old Bedford* c.1889
Oil on canvas
765 x 638
T02039
(This painting will not be on display between May and August 1989)
This picture has been dated to 1890, shortly after Minnie Cunningham began her career as a variety entertainer in the London music halls. It was exhibited in 1892 as 'Miss Minnie Cunningham "I'm an old hand at love, though I'm young in years"'. Minnie first appeared in the Old Bedford in July 1889. The Old Bedford was one of the few surviving music halls from earlier in the century, and because of this was one of Sickert's favourites. He preferred both the ambiance and the architecture of the halls built in the 1860s, frequenting the bourgeois music halls of less fashionable parts of London rather than the up-to-the-minute West End music halls. He deliberately sought out the old-fashioned. In an article of 1910

Sickert reminisced: 'In the Old Bedford Music Hall, the dear old oblong Bedford, with the sliding roof, in the "days beyond recall" before the Music Halls had become two-house-a-night wells, like theatres to look at...'.

Music halls took off in the 1850s and by 1866 there were 33 large halls in London, and several hundred smaller ones. Music halls met much opposition from middle class reforming and temperance societies, partly because of the sale of alchohol in the auditorium. Ironically, it was not these pressures, but rather the internal evolution of the industry itself which caused the changes which Sickert among others lamented. The bigger halls expanded at the expense of the smaller halls as managers recognized investment opportunities through increased exploitation of the artists, improvement of the halls and a general 'cleaning-up' of the act. The growing vigilance of the London County Council over licensing and safety standards also contributed to the demise of smaller concerns. As halls got bigger, drink and tables were removed, and as fixed stall seating replaced single chairs, the stars were increasingly distanced from the audience. Although the West End halls had always attracted fringe elements from the upper class, the bulk of the audiences were male artisans and the better-off tradesmen. It was not until the later 1890s, with the new 'Order and Decorum' that some of the suburban halls at least began to cater for a family audience.

In an article entitled 'The Blight on the Music Halls', written as early as 1899, Max Beerbohm also lamented 'the wasted glories' of the old music halls; 'Reason, variety, refinement have crept gradually in, till one shall sigh in vain for the fatuous and delightful days'. 'I insist that vulgarity is an implicit element of the true Music Hall. Why should we have sought to eliminate it?' The Old Bedford was built in 1861, and was attached to the Camden Arms on Camden High Street. It was known as the Family Theatre, and was Marie Lloyd's favourite. After a fire it emerged again in 1899 as the New Bedford, which was in use until 1950, and was demolished in 1963.

Sickert's early theatre paintings show the influence of Degas in the compositional arrangements, and of Whistler in the long liquid washes of dark paint. Sickert drew and painted other singers in the Old Bedford, including Vesta Victoria and Little Dot

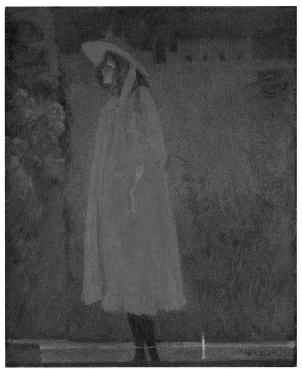
Catalogue 1

Hetherington, and many versions of the theatre's interior. Although there was a solid tradition of painting actors in their role costumes (as Whistler had done), painting the interior of the theatre was much more unusual. Its precedents lie rather in the graphic art of Germany and England of the mid- and early nineteenth century. Sickert was innovatory in his choice of theatre subjects, influential in popularizing this subject matter, and ironically, a symptom of their changing place in British culture.

Figures in a Box
Ink and chalk on paper, heightened with white
305 x 248
Walker Art Gallery 5320
It is not certain whether 5320 is a drawing of an English or a Parisian music hall. Roger Billcliffe inclines towards the latter subject, and dates the drawing to c.1906-7.

Seven Music Hall studies
Pencil on paper, 5486 ink on paper
Walker Art Gallery 5483-5489
'Music Hall Actress in a short Skirt seen from behind' 140 x 90, 'An Orchestral Conductor, seen from behind and Orchestra' 203 x 133, 'Two Figures in an Audience and Page Boy' 100 x 67, 'Studies of a Music Hall Singer in Top Hat' 181 x 114, 'Head and Shoulders of a Young Man in an Audience' 147 x 92, 'Man in Knee Breeches' 120 x 61, 'An Actress on a Stage' 167 x 108

Nine Auditorium Drawings
Pencil on paper
Walker Art Gallery 5310-5318
'Figures in an Auditorium' 92 x 118, 'Man Standing, seen in a Theatre Mirror' 159 x 100, 'Figures in an Auditorium' 86 x 119, 'Figures in an Auditorium' 100 x 118, 'Music Hall Gallery with Figures' 205 x 127, 'Figures in an Auditorium' 93 x 117, 'Figure in an Auditorium' 87 x 154, 'A Bowler Hat' 57 x 38, 'Figures in an Auditorium' 94 x 180.
5311 corresponds to the painting 'The Old Bedford' in the Walker Art Gallery, which was exhibited in 1895 under the title 'The Boy I love is up in the Gallery'. 5314 is a drawing of the 'Old Met', Edgware Road.

Ten Music Hall Drawings
Pencil on paper
Walker Art Gallery 5300-5309
'Studies of a Music Hall Singer' 152 x 100, 'A Singer on Stage' 162 x 98, 'Woman in a White Dress on a Stage' 152 x 100, 'Bessie Bellwood' 73 x 111, 'The Lloyd Sisters' 118 x 84, 'Two Studies of a Singer' 132 x 100, 'Woman in a Hat' 165 x 116, 'Singer in a Hat and Long Hair' 150 x 98, 'Singer on the Stage, seen through the Audience's Hats', 135 x 74, 'Woman on a Stage' 100 x 132.
5302 should be dated to c.1888-1890. The inscription, 'It's not the hen...' on 5307 refers to a song sung by Minnie Cunningham. The figure is close to a drawing of her by Sickert which appeared in *The Idler* in 1895. 5309 probably shows one of the Lloyd sisters, and would be a study for a painting of them dated to c.1888-90.

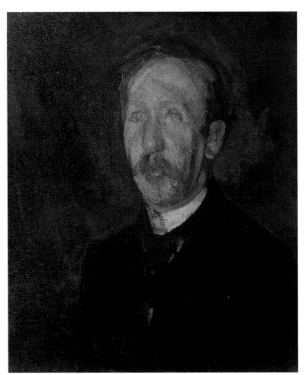

2. *George Moore* 1890-1
Oil on canvas
603 x 502
N03181
(This painting will not be on display between May and August 1989)

George Moore (1852-1933) was a novelist and critic, active in informing the English about contemporary French art. He returned to London from Paris in 1881, but retained his French connections. He met Sickert in Dieppe, and Sickert appears to have held him in mocking affection, amused by what he saw as the inconsequence of his art criticism. As art critic for the *Speaker* he supported the 'Impressionism' of the members of the New English Art Club (NEAC), which Sickert had joined two years after its foundation in 1886. Sickert sided with the 'Impressionist nucleus' in this club. Moore was one of the colleagues from the 'Vale' years – when Sickert was part of the Chelsea community of artists – who lost contact with Sickert when he settled in North London after his return from Dieppe in 1905. Moore recalled that he 'only sat twice for the astonishing and now celebrated portrait, and when, owing to a press of work, I was compelled to abandon sittings, the portrait was chaos. But Mr Sickert had got from me all

he wanted.' Surviving drawings reveal the extent to which Sickert relied on them not only for note-taking, but even for technique, for the drawing style is carried through into the painted version.

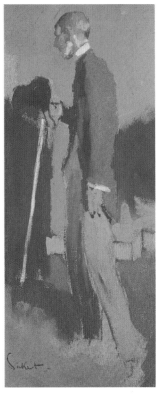

3. *Aubrey Beardsley* 1894
Oil on canvas
762 x 311
N04655

Beardsley (1872-1898), the graphic artist, was at this period the art editor of the *Yellow Book*, to which Sickert contributed some illustrations. Beardsley was close to the NEAC group, and a regular visitor at their gatherings both in Chelsea, and in Dieppe. The picture is said to have been inspired by Beardsley's attempt, at the unveiling of a bust to Keats in Hampstead Church, to slip away from the crowd by taking a short cut through the graveyard. MacFall recalled, 'There was something strangely fantastic in the ungainly efforts... by the loose-limbed, lank figure so immaculately dressed... his pallid, cadaverous face grimly set on avoiding falling over the embarrassing mounds that tripped his feet.' As MacFall's recollections were written long after the event, in 1928, they may well have been coloured by Sickert's painting.

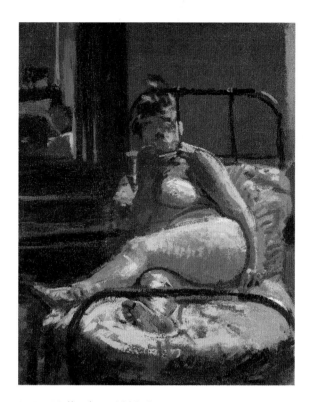

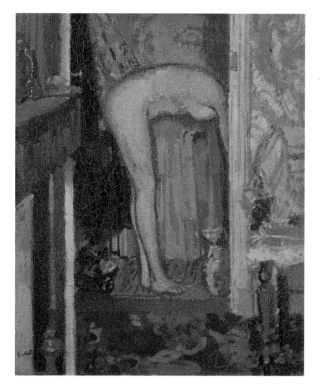

4. *La Hollandaise* 1905-6
Oil on canvas
511 x 406
T03548

Sickert probably painted this soon after his return to London from Dieppe; it is one of several nude paintings of early 1906, painted in the various studios he was hiring in the Bloomsbury-Camden Town area. The nude is painted in an economical, summary manner, but nevertheless answers Sickert's requirement that the figure, in 'the definite light and shade of ordinary rooms' replaces 'the blank monotony of the nude on a platform, with its diffused illumination of studio light'. In the following years Sickert became eloquent about the poetry of *somewhere*, even if that 'somewhere' be simply a 'London square in sunlight, a kitchen, a staircase' in comparison to the monotony of the art-school *nowhere*. 'La Hollandaise' may refer to a character from Balzac's *Gobseck* (an author Sickert greatly enjoyed) in which the prostitute Sara Gobseck is known as 'la belle Hollandaise'.

5. *Woman washing her hair* c.1905-6
Oil on canvas
457 x 381
N05091

In the autumn of 1906, Sickert went to Paris, where he stayed in the Hotel du Quai Voltaire. In the hotel room he painted a series of pictures, most of which were nudes. These paintings are much more composed and controlled than the nude paintings which immediately preceded them. Their shallow planar space, with its interest in the horizontals and verticals of the hotel room, gives the impression that Sickert had been influenced by the paintings of Bonnard's circle then on show at the Salon d'Automne.

Sickert later recalled that he 'had the most enchanting little model the thinnest of the thin like a little eel, and exquisitely shaped, with red hair.' She 'called the part she sat upon "*ma figure de dimanche*"'. This picture, like several others in the display, leads the eye to the centre from a diagonal coming in from the left. Both its composition and its intimate nature remind one that Sickert had picked up Degas' concept of painting a scene as if it were viewed through the keyhole.

6. *Despair* c.1908-9
Pencil
270 x 200
N03183

'Despair' is very close to the male figure in 'Dawn, Camden Town', a painting in the collection of the Earl and Countess of Harewood. This painting was described by the *Yorkshire Observer* as 'a British navvy fully dressed and a dirty complexioned woman with nothing to cover her at all sitting back to back upon a small bed in an East London attic.' Wendy Baron has noted the legend 'Fat Girl' under the mount and suggests that this makes it likely that the drawing was indeed a study for this painting. However, a Tate conservator has identified the words as reading 'Fatigue'. Sickert had begun to combine his single female nude studies with a clothed man around 1908. The immediate sense of a narrative supplied by the combination of two characters led Sickert to play on this with his title 'The Camden Town Murders'. (The Camden Town Murder involved a young glass-painter, Robert Wood, and his murder of an ex-prostitute in 1907.) In these paintings, and in his written defence of them, Sickert was asserting his right to a subject-matter denied painters by 'public propriety'. In a memorable passage of

1910 he described the way a painter should follow his model (the Tilly Pullen of the passage) out into her ordinary life, rather than dressing her up in artificial finery.

But now let us strip Tilly Pullen of her lendings and tell her to put her own things on again. Let her leave the studio and climb the first dirty little staircase in the first shabby little house. Tilly Pullen becomes interesting at once. She is in surroundings that mean something. She becomes stuff for a picture.

Sickert insisted that only the human, and all that it entailed ('the ways of men and women, and their resultant babies') could really put the thrill into paintings.

7. *L'Américaine* 1908
Oil on canvas
508 x 406
N05090

While at work on this picture, Sickert wrote to a correspondent, 'I am deep in two divine costergirls – one with sunlight on her indoors. You know the *trompe l'oeil* hat all the coster girls wear here with a crown fitting the head inside and expanded outside to immense proportions. It is called an "American

sailor" (hat)'. The strong touches of colour are common to his paintings of this period, and by the following year they had become even more strident.

Three Studies of Heads, two of which are of a woman in a hat
Chalk and ink on paper
305 x 248
Walker Art Gallery 5504
These studies in fact relate to Sickert's paintings of the Parisian theatre 'Gaité Rochechouart', notably the one in Aberdeen. They probably date to around 1905, although the painting is of 1906-7.

as models painted 1909-16. Notable among these evolving themes are 'Sunday Afternoon' and 'Jack Ashore'. 'Hubby' joined the Sickert household as an odd-job man around the studio in 1911. If this painting dates from 1911, as Wendy Baron and Richard Shone suggest, then it is the first to feature Hubby.

Off to the Pub
Pen and pencil
267 x 216
Arts Council of Great Britain

9. *Rowlandson House – Sunset* 1910-12
Oil on canvas
610 x 502
N05088
Rowlandson House was situated at 140 Hampstead Road, London. It was the location of the school which Sickert had founded a little earlier in 1910 across the road at number 209. In Rowlandson House he at first taught etching, with Madeleine Knox, and later, with Sylvia Gosse, both etching and painting. The school was closed soon after the outbreak of war – it had nevertheless been the most long-lived of Sickert's art schools – and Rowlandson House is now demolished. Sickert did few paintings of the London

8. *Off to the Pub* c.1912
Oil on canvas
508 x 406
N05430
There are two paintings entitled 'Off to the Pub' which show the same subject but with different compositions. Other anecdotal titles given to this kind of theme include 'A Few Words' and 'A Tiff'. These paintings are a subset within a larger series of Camden Town interiors with 'Hubby' and Marie Hayes

landscape, and the studies of Rowlandson House occur in the period 1910-12 when he was more interested in the subject. Another watercolour of the house shows it with bunting out to commemorate George V's wedding in June 1911, and its garden is featured in two illustrations of August and July 1911 in the magazine *The New Age*: 'The Little Master' and 'Londra Benedetta'.

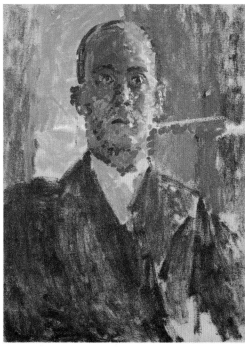

10. *Harold Gilman* c.1912
Oil on canvas
610 x 457
T00164

The painter Gilman (1876-1919) met Sickert in 1906, and this portrait could in theory have been done any time between 1906 and 1919, the year of his death. However, a quarrel broke their friendship in 1915, and the bright coloration and technique of the painting suggest a date of c.1912. Gilman is also the subject of various drawings by Sickert from this period. At Sickert's home in 19 Fitzroy Street, Gore, Lucien Pissarro, Augustus John, Henry Lamb, Gilman and Sickert gathered together to present studio exhibitions. Gilman later persuaded these painters to break with the NEAC, and they formed the Camden Town Group in 1911. Before this group was merged into the London Group they held four important exhibitions.

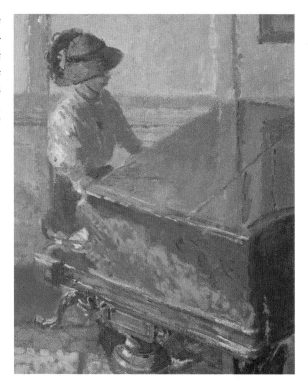

11. *Tipperary* 1914
Oil on canvas
508 x 406
N05092

This picture takes its title from the war-time song of 1914, when the picture was painted. It was probably painted at the artist's Red Lion Square studio, where he had a grand piano. Sickert painted several piano pictures during the first winter of the war, and in relation to one of these, he wrote to a correspondent, 'Chicken has been playing the *Contes d'Hoffmann* while I have been painting her reflection at the piano'. He had already embarked on this theme in the summer of 1914, writing from Dieppe that he 'had begun a study of Tavernier's daughter at the piano… It is pleasant to draw and listen to Beethoven'. In the Tate's picture the model Chicken is shown playing alone, while in another of the same title (in a private collection) she is shown with a soldier. Another study, similar to the Tate's picture, entitled 'The Baby Grand', is known to exist.

The Piano
Ink on paper
270 x 210
Walker Art Gallery 5411

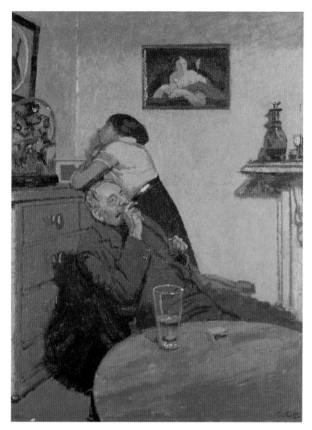

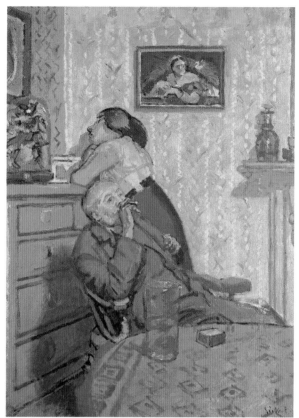

Ennui c.1918. Oil on canvas, 762 x 559.
Oxford, Ashmolean Museum. (Not in exhibition)

12. *Ennui* c.1914
Oil on canvas
1524 x 1124
N03846

The Tate's version of 'Ennui' is the most highly finished of five canvases. It is also the culmination of a long-line of two figure interior pictures. It was first exhibited in the NEAC in 1914. Two versions date from c.1913 and may be considered preliminary versions of the Tate picture, neither includes the table. Another is dated 1916, and represents a 'close-up' of the figures. The Oxford version (c.1918?) is a half-scale version of the Tate picture, but with the plain passages transformed into patterned areas. It was the Oxford painting which inspired Virginia Woolf in *Walter Sickert: A Conversation* of 1934. There are several composition studies and detail studies for this painting, and Sickert also etched it in 1915.

'Ennui' was an important test painting for Sickert, in which he enlarged his painting up to near life size, rather than keeping to the scale of actual vision, a principle to which he had adhered until then. He was also keen to work on a larger scale so as to maintain

the delicacy of undiluted paint. He found that, on a life-size scale 'the execution becomes beautiful, the surface no longer congested'. He now required only that the studies from life be made on the scale that they were seen, and improved on these for the final painting by squaring them up. He maintained the tightness of the composition by concentrating on drawing the interlocking of several objects, and maintained correct proportions by constantly referring to the horizontal and the vertical. Helen Lessore remembered, 'When he talked about squaring drawings up for a painting, he said how very important it was that it should be mathematically exact because the whole magic of the thing depended on the absolutely precise relation of the placing of these things, which you'd caught in your drawing, and that when you squared it up it must be absolutely true to a fraction because that was where the secret lay, really, in the precise relation of every mark to every other mark'. This process is revealed in the squared up drawings, and Sickert also used a *grille* or adjustable rectilinear grid with which he could compare the 23

original drawings and the canvas on which he was working. The grille meant that he was able to scrub thin layers of paint onto the canvas, and then to recover the original lines of the drawing. Sickert admired Solomon J. Solomon for his 'insistence on drawing by the *background shape*' and declared, 'I am … with him, heart and soul, for incessant plumbing'. There is a strong sense of this stability and gravity in 'Ennui'. The painting gives the impression of having been stretched beyond the subject's natural size. Nevertheless, the sense of strain in the picture does add to the psychological tension which we read into the relationship between the two characters. It was painted in Sickert's studio on the corner of Granby Street and Mornington Crescent.

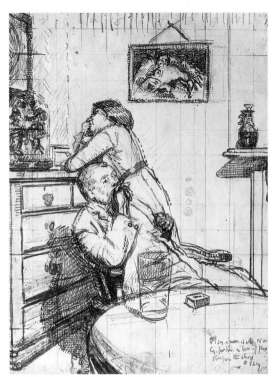

Study for 'Ennui'. Oxford, Ashmolean Museum.
(Not in exhibition)

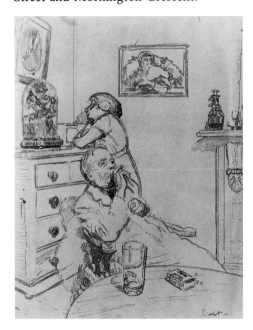

Study for 'Ennui' 1913–14
Sepia ink on brown paper
419 x 340
T00350

Ennui c.1914–31
Etching
225 x 162
P11050

Woman with her Head on a Man's Shoulder
Ink on paper
149 x 209
Walker Art Gallery 5382

24

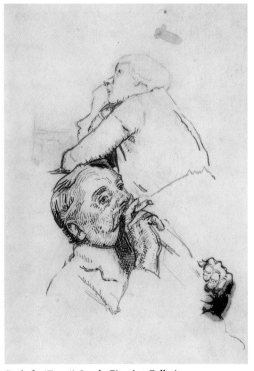

Study for 'Ennui'. Leeds City Art Galleries.
(Not in exhibition)

Study for 'Ennui'. Oxford, Ashmolean Museum.
(Not in exhibition)

Study for 'Ennui'. Leeds City Art Galleries.
(Not in exhibition)

13. *The New Bedford* 1915–16
Oil on canvas
914 x 356
N06174
(see illustration on back cover)

Sickert returned to the site of the Bedford Music Hall around 1907. The Old Bedford, destroyed by fire in 1899, had been rebuilt as the New Bedford. Initially Sickert appears to have avoided its new showy interior, and chosen to work in other halls, but he soon came to revel in its opulence. He painted several versions of it in the years before the Tate's picture. In 1914 Sickert also embarked on a decorative scheme for Miss Ethel Sands' dining room, which featured the New Bedford, and this project led him to spend many evenings drawing in the theatre, planning her mural scheme. Many of these drawings are now in the Walker.

In Harold Scott's history of the music halls, he writes that by 1918 'the Music Hall was already half dead, robbed by events of its genuine psychological and social background'. However, in the following years, 'some elements reappeared in the form of *pastiche … revivals of "Old Music Hall" cropped up'* at, for instance, one of Sickert's favourite halls, Collins' at Islington.

Tier of Boxes in a Theatre and Part of a Stage, Pencil on paper, 159 x 202 and *Figures sitting in a Box,* Ink and Chalk on paper, 149 x 92
Walker Art Gallery
5393-5394
5394 can be dated to c.1914–15

Corner of Stalls and part of Dress Circle, The New Bedford
Ink, Chalk and wash on paper,
324 x 132
Walker Art Gallery 5401

Seven Studies of the New Bedford
Various media
Walker Art Gallery 5395-5400 ; 5532
'Studies at The New Bedford, Camden Town', Ink and chalk on paper, 324 x 135, 'The Top of a Box', Pen, chalk and charcoal on paper, 320 x 127, 'A Box with a nude plaster statue', pencil on paper, 323 x 134, 'Woman in a Box', pen on paper, 25

149 x 95, 'Study of the Top of Box', Chalk on paper, 110 x 200, 'The Entrance beneath a Box', Charcoal and ink on paper, 149 x 94, 'Study of the Top of a Box', Chalk on paper, 111 x 200. 5398 is close to the Tate picture; note the girl in the wide hat leaning on the balcony. 5532 is probably a study of 1913-14, used for the Ethel Sands commission.

Curve of a Dress Circle (Gaité Montparnasse)
Black and white chalk and ink on paper
325 x 249
Walker Art Gallery 5356

Noctes Ambrosianae
Etching and aquatint
Plate mark 222 x 254; Print surface 181 x 221
Walker Art Gallery 5143
(The Old Mogul Tavern, 1906)

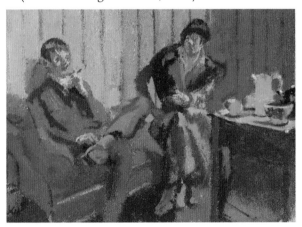

14. *The Little Tea Party: Nina Hamnett and Roald Kristian 1915-16*
Oil on canvas
254 x 356
N05288
This was painted in 1915 or 1916 in 8 Fitzroy Street, Whistler's old studio. In her autobiography, Nina Hamnett, a painter and close colleague to Sickert in this period, remembers how she and her husband, whom she refers to as Edgar, sat for Sickert: 'Edgar and I sat for him together, on an iron bedstead, with a teapot and a white basin and a table in front of us. We looked the picture of gloom.' Two studies for this painting apart from that in the Tate are known; one in Huddersfield in pencil, pen and ink, the other in watercolour. Sickert painted a number of portraits

of his friends in his studio in this period, moving away from the more charged 'private' paintings of the pre-war period. A pencil study of Roald Kristian was exhibited at the Parkin Gallery in 1986; it was inscribed 'De Bergen', Kristian's original name.

The Little Tea Party
Black charcoal heightened with white on grey paper
230 x 355
N06519

The Little Tea Party
Pencil, pen and ink
254 x 351
Kirklees Metropolitan Council,
Huddersfield Art Gallery

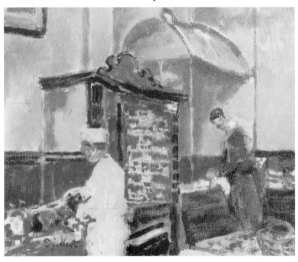

15. *The Tottenham Distillery c.1924*
Oil on canvas
508 x 610
N05086
The setting of this picture may be the pub The Tottenham, at 6 Oxford Street, where Sickert used to lunch. However, in an article in *The Burlington Magazine* of August 1943, the Slade Professor Randolph Schwabe mentioned the Tottenham Distillery near the Slade School as 'an old fashioned tavern where the food was good'.

Dieppe was the first bathing resort in France, and in the 1820s enjoyed the patronage of the Duchesse de Berri. By 1870 it had an English community of 2,000. Jacques-Emile Blanche, friend to Sickert, and a fervent Dieppois, recounted that the terrace of the Café des Tribunaux (one of Sickert's favourite subjects) was full of 'English artists of the Victorian era'. Dieppe was not only associated with English artists, it had a line of French artists going back to Delacroix through Corot, Daubigny and Boudin. By the time Sickert first encountered the Blanche household at Dieppe in 1885, Pissarro, Renoir, Monet, Gauguin and Helleu were all regular visitors there. Dieppe continued to attract foreign artists too, and Whistler, Sargent, Charles Conder and Aubrey Beardsley frequented the Blanches. Blanche's friendship with Degas enabled Sickert to cement this connection. 'Eight months out of twelve, Paris and the universe arrived in Dieppe', wrote Blanche. 'The reopening of the Casino bazaar, the unwrapping of the couture collection by Marion, rival to Worth, the appearance of the first list of foreigners in the *Gazette Rose*. Fatal double life for the residents of bathing resorts!' Certainly by 1901 Sickert himself was able to see Dieppe in this light: 'I ... see it a little as that terrible compliment, the watering-place-out-of-the-season'. Although Dieppe changed after the war, it maintained its society appeal. 'The Old English colony in the town of Dieppe was shrinking, but the bathing seasons were still fashionable ...'

Dieppe had family associations for Sickert through his mother, who had been educated in an English school at Neuville-lès-Dieppe. He spent the summers there painting landscape from the 1890s until 1914, and was based there permanently between 1898 and 1905. On his honeymoon he stayed in the Rue Sigogne, and in 1898 had several addresses in the town. Between 1899 and 1902 he lived with his mistress Augustine Villain in Neuville, and kept on accommodation in Neuville until 1911, when he moved to Envermeu, a hamlet six miles outside the town. At Envermeu he stayed first in the Villa d'Aumale, and after 1919, in the Maison Mouton. He

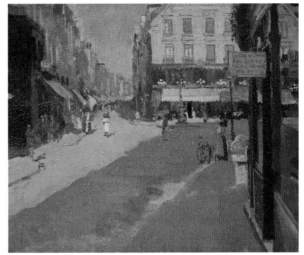

Catalogue 16

was again based permanently in Dieppe between 1919 and 1922. Blanche described him as 'the squire of Neuville', and the fact that Sickert chose to live outside the town might incline us towards the idea that he passed a comfortable, residential life. In 1913-14 Sickert does appear to have spent most of his time in Envermeu, engaged unusually on rural studies, but as a general rule this impression would appear to be misleading. As Blanche recounts, 'Walter went out to paint in the streets; he rented mysterious rooms in the harbour quarters, sheds from which all were excluded, where he prepared his canvases, his wooden panels, and stowed his portfolios of drawings carefully squared up...' And later, 'Though he lived at Envermeu, he secretly rented rooms at Dieppe as he had done in the old days and went there by train.' 'I envied Sickert, who rented five or six rooms, whose addresses he kept secret, hangars where he hid his mistresses and his pictures.'

After Christine's death in 1920, Sickert moved into town, renting first a flat at 44 Rue Aguado (where he had already rented rooms as early as 1914), and later at 10 bis Rue Desmarets. He returned to London in 1922, and spent the next two years 'winding up' much of his Dieppe based work.

16. *Café des Tribunaux* c.1890
Oil on canvas
603 x 730
N03182
(see illustration on previous page)

Sickert had etched the Café des Tribunaux in 1885, and this etching is close to a picture in the National Gallery of Canada. In this painting part of another favourite Dieppe subject – the church of St Jacques is visible at the end of the street on the right of the café. The Café des Tribunaux stood in a square which was a popular meeting place in the centre of Dieppe. The handling of the paint in the Tate version marks the way in which Sickert continued to paint most of his Dieppe subjects over the next few years. Sickert has assimilated the lessons learnt from Whistler, and has gone beyond them to manipulate the paint in his own manner.

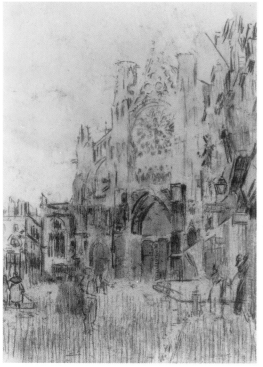

17. *Dieppe, Study No 2; Façade of St Jacques* c.1899
Chalk and wash
321 x 232
N05094

A view of the western façade of the church of St Jacques in Dieppe, one of Sickert's favourite motifs, which he had painted from the 1880s. Most of the many extant versions date from 1899-1900, and

range from oil on canvas, panel paintings, to studies in various media. A well-known painting of 'St Jacques Façade' in the Whitworth Art Gallery, Manchester is not dissimilar to the Tate drawing. However, the drawing does not appear to be a direct study for any painting. It is closest to a canvas last known in a private Canadian collection, and to two panel paintings in English private collections. The view is close to that which Sickert chose for the projected decorative scheme of four large panels commissioned by a Dieppe café owner in 1902. Sickert had gone to live in Dieppe in 1898, and stayed there until 1905. In this period Sickert painted a great deal of outdoor landscape scenes, and this is not unconnected with his growing interest in the 'picturesque', and with the fact that he had found London lacking in sufficient light for anything except portraits. His interest in light is clearly revealed in the St Jacques series which depicts the church under different lighting conditions. St Jacques is one of Sickert's repertoire of Dieppe subjects, comprising the Hôtel Royal, the statue of Admiral Duquesne, the Rue Notre Dame, the Quai Duquesne and the Rue Pecquet.

Street Corner with Cathedral,
Traced drawing and pencil on paper
273 x 203
Walker Art Gallery 5526

There is a painting of this subject which Wendy Baron dates to 1899-1900. This drawing is unusual in that it is one of only three drawings of this period not executed in a colour wash or pastel. This would suggest that this was very much a working drawing, and never intended for sale.

18. *Les Arcades de la Poissonnerie, Dieppe* c.1900
Oil on canvas
610 x 502
N05045

The paintings that Sickert did of the town of Dieppe reveal a freer and much more fluid approach to the paint than those he had done in Venice. Black lines are used, but lie on the surface rather than containing the drawing. He was interested in working lightly and loosely, achieving this by using varnish and turpentine. The grey ground he was using at this time for his canvases lends a sombre air to many of the Dieppe paintings. The Arcades de la Poissonnerie

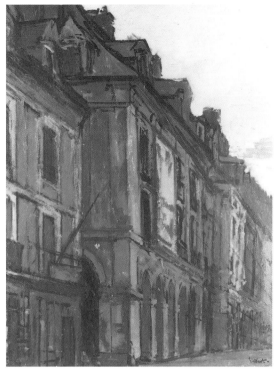

Catalogue 18

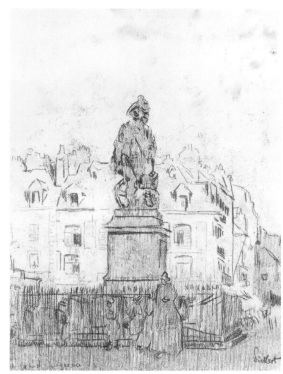

Catalogue 19

front the Quai Duquesne, and Dieppe harbour lies to the right. The Rue Notre Dame which is off to the left of this scene leads up to St Jacques, and was another favourite subject for Sickert.

19. *Sketch for 'The Statue of Duquesne, Dieppe'* c.1902
Pastel and watercolour
324 x 235
N05096

This sketch relates to a painting of c.1899 in the collection of Victor Montagu, which is itself a small version of the painting from Manchester City Art Gallery, which was painted on commission in 1902, intended as one of the four panels to decorate a Dieppe café. This commission was important in challenging Sickert to work on a large scale, although he ended by selling the four paintings to an American living in Dieppe. The series comprised 'La Rue Notre Dame', 'The Statue of Duquesne', 'St Jacques' and 'The Bathers' (now in the Walker Art Gallery). The statue of Duquesne is in the Place Nationale, and Sickert painted it many times. Sometimes he provided it with fictional backgrounds, such as the

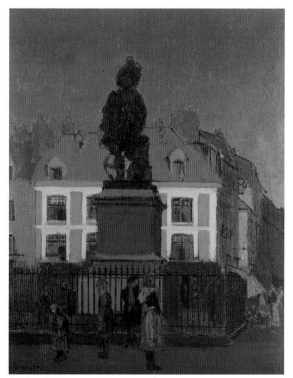

Le Grand Duquesne, Dieppe 1902
(for details see over)

church of St Jacques. The statue was the work of the sculptor Dantan, whom Sickert revered and collected in a small way. In the period 1899-1900 Sickert executed many coloured drawings of outdoor scenes in Dieppe. Many of them are not preparatory drawings for paintings, and were simply executed for quick sale. Although he wanted to make the most from 'his goldmine' Dieppe, he was unsure at first about his ability to make saleable drawings, but was reassured by two London dealers. Some of them are drawings from drawings, and some even appear to have been traced.

Le Grand Duquesne, Dieppe 1902
Oil on canvas
1302 x 1003
Manchester City Art Galleries
(see illustration on previous page)

20. *Jacques-Emile Blanche* c.1910
Oil on canvas
610 x 508
N04912

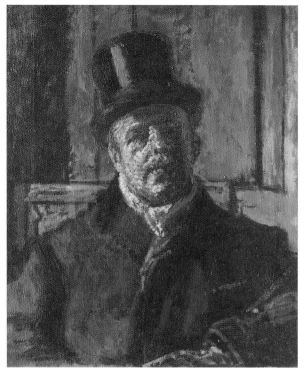

Catalogue 20

Blanche, a painter and critic, was a close friend to Sickert from 1885, and very much responsible for integrating him into Dieppe artistic and intellectual society. It was at Blanche's house that Sickert encountered Degas again in 1885, and Blanche identified his influence in Sickert's new interest in 'figure-drawing, the decorative and architectural pattern'. He also helped establish Sickert with the Parisian dealers Durand-Ruel and Bernheim Jeune. Blanche had Sickert elected to the Salon d'Automne in 1906, found him teaching in Paris, and introduced him to potential patrons such as André Gide, while buying a large number of Sickert's works himself. Both men were equally at home in London and Dieppe. Though they had been so close, by the time this portrait was painted, that friendship was cooling, and Sickert was beginning to dismiss him as gloomy and trivial.

Catalogue 21

21. *Roquefort* c.1918-20
Oil on canvas
410 x 324
N03847

The still lifes of food done at Sickert's house at Envermeu outside Dieppe 1919-1920 represent the only cohesive still life series that Sickert ever executed. Wendy Baron identifies in them 'his sense of well-being, the happy acceptance of his domestic life during the brief time which he and his wife enjoyed together in their French home after the privations of the war'. Apart from 'Roquefort' he painted a lobster, red currants and the preparation of an omlette. It is likely from the fresh appearance of the thin scrubs of paint that Sickert painted directly from nature. This series ended with his wife's death, and Sickert attributed its cessation to the association with Christine. In 1922 he wrote 'When Christine was alive, I loved the landscapes there (at Envermeu), because they seemed to belong to her, and the still lifes too, because they were seen in her house'.

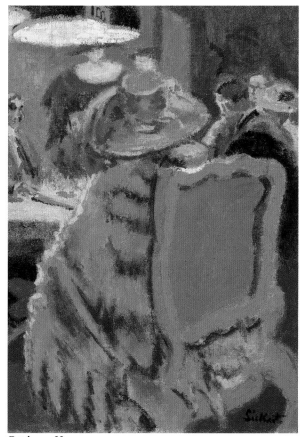

Catalogue 22

22. *Baccarat – The Fur Cape* 1920
Oil on canvas
591 x 419
N05089

Soon after Christine's death Sickert moved from Envermeu to Dieppe. The 'Baccarat' series from the Casino, and the café-concert paintings at Vernet's, date from around this time. Sickert often visited Vernet's before going on to the Casino. A letter of 1922 illustrates how these studies fitted into his work routine: 'I shall work, as I do now, from 10 to 4 by daylight, & 4 to 7 by artificial light, & frequently draw at music halls too from 8 to 11'. The Casino, unlike Vernet's (and unlike Sickert's other leisure subjects), represents the entertainment of the leisured classes. Blanche described how after the war a 'huge, concrete fortress, a *modern style casino*' replaced the charming old building. 'Everything was sacrificed in order to attract people to play baccarat, roulette, and indulge in other expensive pleasures.' Sickert used several variations of the groupings of figures around the tables in the Casino, illuminated from above, and these include 'The Fur Cape', 'The Old Fool' and 'The System'. The treatment of the figures remind one of Sickert's earlier employment as a caricaturist. The sharp colours of the baize tables and clothes suited his new range of colours. Browse reports that Sickert's drawing activity in the Casino led Lady Blanche Hosier to complain to the management, afraid that she would be recognized in his paintings. Thereafter Sickert was forced to make small sketches on little cards under the table. Sickert painted several pictures of gamblers at play in the Dieppe casino. A similar sketch, dated 1920, was exhibited in 1982 under the title 'Villeggiatura' (or 'Vacationing').

Studies for 'Baccarat'
Pencil on paper
Walker Art Gallery 5418-5419
'A Woman and Three Men seated at a Table' 271 x 211, 'Croupier at a Table', 125 x 142

Studies for 'Baccarat'
Pencil on paper and pencil on card
Walker Art Gallery 5435-5436
Study for 'Baccarat' 213 x 136, Study for 'Baccarat' 140 x 90
5346 was one of the small drawings made after

Sickert was asked to stop drawing; more of these small cards are in the Ashmolean Museum, Oxford.

Studies for 'Baccarat'
Pencil on paper
Walker Art Gallery 5415–5417
Studies for 'Baccarat' – 'A Woman's Hat' 270 x 211, – 'Woman seen from Behind', 271 x 211, – 'Woman sitting at a Gaming Table', 270 x 211

Interior of a Café Chantant (Vernet's, Dieppe)
Pencil, ink and wash on paper
349 x 225
Walker Art Gallery 5414

23. *L'Armoire à Glace* 1924
Oil on canvas
610 x 381
N05313
(see illustration on front cover)

This painting was set in the furnished flat which Sickert took in the Rue Aguado in Dieppe, but was painted after his return to London. It belongs to a group of four similar genre pictures set in the same setting: 'The Prevaricator', 'La Parisienne' and 'The New Tie' – the only French equivalents to his Camden Town series. A letter from the Rue Aguado of November 1921 explains, 'I have sittings by electric light nearly every day in my flat at no 44 and am deep in figure subjects again'. He continued, 'Marie's niece goes off like a hot cake I have sent for her again today 5–6 by electric light at no 44 to do some more canvases'. The model was Marie Pepin, his maid since 1911. The scene must have been studied in 1922, for an engraving and a drawing of the scene bear this date. A story has been given the picture by the quotation inscribed by Sickert on this engraving: 'Moi, mon rêve ça a toujours été d'avoir une armoire à glace', and by his account of it in a letter to his friend Stephenson in Southport:

a sort of study à la Balzac. The little lower middle-class woman in the stays that will make her a client for a surgeon & the boots for a chiropodist, fed probably largely on "Ersatz" or "improved" flour, salt-substitutes, dyed drinks, prolonged fish, tinned things, &, sitting by the wardrobe which is her idol & bank, so devised that the overweight of the mirror-door would bring the whole structure down on her if it were not temporarily held back by a wire hitched on an insecure nail in insecure plaster. But a devoted unselfish uncomplaining wife & mother, inefficient shopper & atrocious cook.

It is unusual for Sickert to provide such a wealth of supplementary 'information' to a picture, but he did maintain that great painting was illustration and rejoiced in the 'progress' of 'the intensity of dramatic truth in the modern conversation piece or genre picture'. There are two pen and watercolour studies for the composition in private collections, and the Fitzwilliam Museum possess a pen and ink drawing without the background. Another pen and ink sketch, squared up, was sold in 1982 as 'Study for Prout's Parlour'. *(see illustration on far right)*

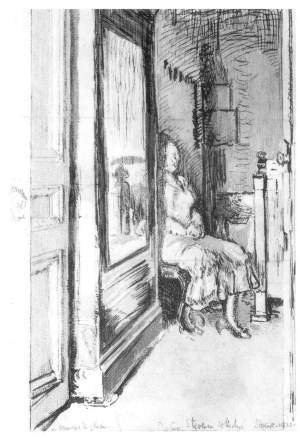

Study for 'L'Armoire à Glace' 1922
Pen, watercolour and crayon
260 x 187
N05312

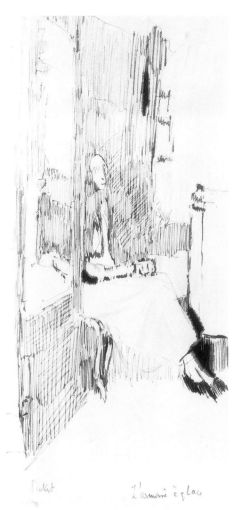

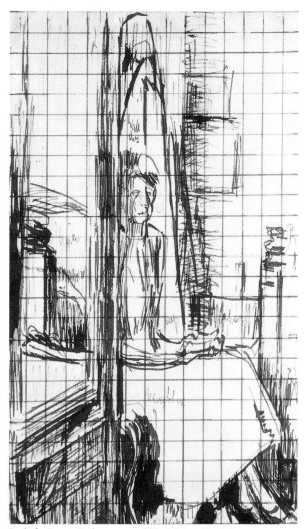

Study for Prout's Parlour, pen and black ink, 248 x 149, present whereabouts unknown. (Not in exhibition)

Study for 'L'Armoire à Glace' c.1922
Crayon, pen and ink
279 x 130
N06087

L'Armoire à Glace
Pen, ink and chalk
293 x 229
Whitworth Art Gallery, University of Manchester

Woman Sitting by a Wardrobe
Pen and pencil on paper
290 x 230
Walker Art Gallery 5410

The New Tie
Etching
Plate mark 270 x 176
Walker Art Gallery 5149

1895 marked the first of several visits Sickert made to Venice; he went again in 1900, 1901 and 1903-4. This first visit may have lasted as long as a year from May 1895. In November 1895 he was staying at 788 Zattere; the following May he was in the Calle dei Frati, San Trovaso. After this first visit he continued to paint Venetian scenes in London. It is possible that he worked from photographs as well as from his notes and oil sketches. In 1899 he referred in a letter to a parcel of 'small-scale drawings, of panels of Venice that is to say St Mark's façade and the Rialto, pen drawings and photographs of sitters and photographs of Venice'.

It should be remembered that several of Sickert's Venetian subjects were painted back in London; the fact that he painted a relatively small repertoire over and over again makes it all the harder to date the several versions. In Venice he concentrated on St Mark's, the Rialto Bridge and the Scuola di San Marco. This building up of a series links the Venetian paintings to the first motif treated in series form – the Old Bedford – both in this respect, and in the free handling of paint, in for instance, the St Mark's interior. The last time that Sickert visited Venice the weather was unusually inclement; this must have encouraged him to paint the seminal series of women in interiors which heralded the paintings he went on to do in London. Sickert did not intend to leave Venice definitively in 1904. But, although he had retained his room at 940 Calle dei Frati, he never returned.

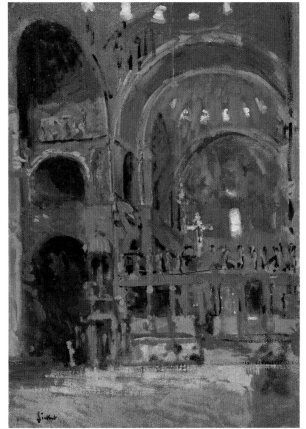

24. *Interior of St Mark's, Venice* 1896
Oil on canvas
698 x 492
N05314

Although only one painting from this first visit is dated, other information allows us to attribute further paintings to this period. In a letter to Steer from 1895 Sickert wrote, 'Venice is really first-rate for work … It is mostly sunny and warmish and on cold days I do interiors in St Mark's.' He found St Mark's 'engrossing'. He thanked Steer for all he had learnt from him: 'To see the thing all at once. To work open and loose, freely, with a full brush and full colour. And to understand that, when, with that full colour, the drawing has been got, the picture is done. It sounds nothing put into words, but it *is* everything put into practice.'

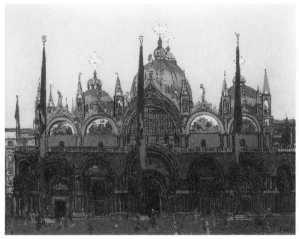

25. *St Mark's, Venice: Pax Tibi Marce Evangelista Meus*
1895-6
Oil on canvas
910 x 1200
N05914

A label on the frame of this painting bears the motto of the City of Venice, *Pax Tibi Marce Evangelista Meus* (Peace be with thee, O Mark, my Evangelist), establishing that this was the picture shown at the NEAC in 1897. This must therefore be another painting from Sickert's first visit to Venice. Sickert painted various versions of this, including oils owned by the British Council and Christopher Loyd, and another in a private collection. The drawing from Manchester appears to be our most important preliminary document for this drawing, and is just under half the size of the painting.

Façade of St Mark's, Venice c.1896
Black chalk and ink heightened with white, with touches of colour on grey paper, squared
460 x 584
Manchester City Art Galleries

Three studies of St Mark's, Venice
Walker Art Gallery 5345-5347
Ink and chalk on paper, 225 x 190, crayon and ink on paper, 267 x 181, crayon and ink on paper, 254 x 190

There are at least four paintings of this particular view of St Mark's, one of which is dated 1901. In the later pictures Sickert focused on a corner of the façade, rather than the whole views of the 1895-6 paintings.

St Mark's, Venice
Etching
Plate mark 238 x 314
Walker Art Gallery 5152

26. *The Piazzetta and the Old Campanile, Venice*
c.1901
Pastel and watercolour
495 x 330
N03810

This composition appears to be a study for the oil painting 'The Piazzetta', while there is another less closely related painting, 'La Piazzetta, Venise crépus- 35

cule'. The drawing must have been done before 1902, when the old Campanile collapsed, and indeed Browse dates it to 1896, although the two oil paintings were done c.1901. The proliferation of Venetian paintings was not without its materialistic side. They constituted the kind of 'bulk' which it profited Sickert to build up, and the dealers were particularly happy to display them. Sickert was prepared to paint to order for an interested client, and would use a selected drawing as the basis for a new painting.

The Piazza San Marco; Venice
Pen and pencil on paper
196 x 264
Walker Art Gallery 5545
This subject does not appear in the paintings from Sickert's first visit to Venice, and as it shows the Loggia intact before it was damaged by the fall of the Campanile, it must date to 1900-1901.

27. *Venice, La Salute* c.1901-3
Oil on canvas
451 x 692
N05093
(see illustration on opposite page)
This was originally exhibited in Paris in 1907 as 'Les Marches de la Salute'. Sickert painted several views of La Salute in the period 1896 to c.1903. In his two trips to Venice in 1900 and 1901 Sickert remained faithful to a small body of well-known subjects (St Mark's and its piazza, the Doge's Palace and Campanile, Santa Maria della Salute), but he also occasionally branched out to paint a less well known church or corner of the town. He was increasingly interested in the close-up view which was sensitive to architectural movement and solidity. This is particularly noticeable in his painting of the horses of St Mark's, and in this painting.

28. *A Marengo* c.1903
Oil on canvas
381 x 457
N03621
The title of this picture may perhaps refer to an old Italian coin, or to the famous battle which Napoleon won in 1800. The figures are similar to those in 'Conversation Piece', but unlike 'Conversation Piece' and 'Caquetores', 'A Marengo' gives the impression

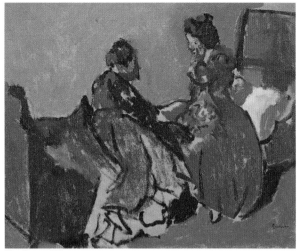
Catalogue 28

of having been drawn from the two figures together, rather than being a composite composition derived from two separate models. In this respect 'A Marengo' is perhaps more closely similar to another Tate picture, 'Le Tose', although a sketch for one of the women in 'Le Tose' suggests that it too may have been compiled from separate studies. Both pictures show one of Sickert's favourite Venetian models, La Giuseppina, whom he painted many times alone or in conjunction with another woman. The Tate thus owns two pictures from this important series of 1903-4 when Sickert abandoned the townscape of Venice, and moved into its anonymous interiors, peopling them with female couples who presage the psychologically charged interiors of Camden.

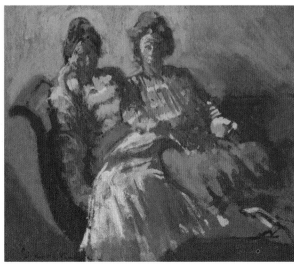
Catalogue 29

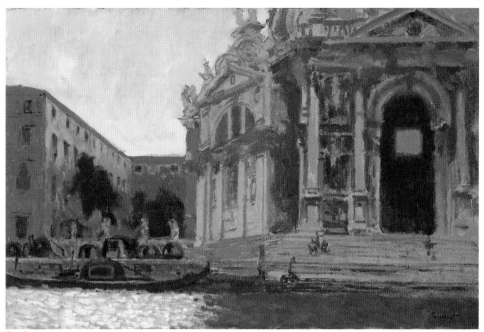

Catalogue 27

29. *Two Woman on a Sofa – Le Tose* c.1903–4
Oil on canvas
457 x 533
N05296
(see illustration on previous page)

'Le Tose' is Italian slang, and might be translated as 'The Girls'.

30. *Pierrot and Woman Embracing* 1903–4
Chalk and wash
410 x 311
N05095

This Tate sketch is a preliminary study for a small panel painting, 'Venetian Stage Scene', now in the collection of Lord Ilford. This was exhibited in 1962 as 'The Porch'. There is another panel painting which represents a study for the upper part of the architecture. The Tate has catalogued this sketch as 1903–4, but Wendy Baron suggests that the style, and a letter of 1901 describing 'the Pierrot and *popolana*' 'on paper' sent to the Fine Arts Society from Venice must date it to 1901. It is an unusual work for this period, when Sickert was mainly involved in land-scape painting. It should perhaps be seen as one of Sickert's theatrical paintings, but its fantasy quality tempts one to see it as a more anomalous excursion into a fairytale vein.

Catalogue 30

Sickert spent some time in Bath during the war, though he never abandoned his studio in London, and indeed frequently returned there. In 1917 he returned to London and lived either there or in Dieppe until 1925. In that year he left 15 Fitzroy Street, and over the next two years he and his new wife Thérèse Lessore spent some time in Margate, Newbury and Brighton. In 1927 Sickert took a studio in Kemp Town, Brighton, which he retained until 1931, even though he returned to live in London in 1927. In 1934 the Sickerts went to Margate for a holiday. Sickert took a studio there, and by Christmas they had settled nearby, at Hauteville, St Peter's-in-Thanet. Here they stayed for four years, settling for a last time in 1938 in St George's Hill House, Bathampton outside Bath.

In Bath between 1916 and 1918 Sickert painted a good deal of townscape. Though he did paint scenes located around his later residences, none of them has anything like the topographical importance to his oeuvre of the earlier locations Dieppe and Venice. This is partly because Sickert was increasingly reliant on indirect sources such as photographs and etchings. From around 1923 Sickert gradually ceased to draw, finding the information and verification he required in other kinds of document. This shift was not merely because of age, although it did of course mean that the painter was not restricted to painting only his immediate surroundings. Photography makes available to the painter a wider world, and Sickert used it to paint a number of portraits of people who never actually crossed the threshold of his studio. Other portraits did feature people whom he knew well and saw often, who would have sat willingly for him, but Sickert deliberately chose to portray them from printed sources. He used both photographs and press cuttings. His use of photography was various; both premeditated and opportune. Clifford Ellis recalled that while in Bath in 1916-1917, Sickert was making very thorough use of photography: 'The photographer would come in the morning, find a message there from Sickert: "Go to Camden Crescent, third

lamp-post on the right, take a photograph facing so-and-so when the sun is in the right direction"'. Similarly, in the theatre, Peggy Ashcroft remembered, 'He used to come both to Sadler's Wells and the Old Vic, and he would bring his photographer and take photographs of what particularly appealed to him in the productions, and from those he did a lot of pictures.' Sickert also used the services of a professional photographer when staging a picture such as 'The Raising of Lazarus' (1929-32) in his own studio. Cicely Hey, the model who features with Sickert in the composition, recounted, 'Well then the photographer took two or three photographs, went away to develop them. Then I went back a few days later when he had an enlargement of the photograph, and he'd got it squared up as he did his drawings, then I stood again. He drew on top of the enlarged photograph and it was that that he used for the preliminary cartoon; two separate photographs'.

The elaborate process was common to both Sickert's work from drawings and his work from photographs. This process is revealed in a testimony by Duncan Grant, who attended a lecture by Sickert in 1938. 'Sickert's method ... is this. He sees a subject – the colonel's house at Bearscip for instance. He has it photographed, he squares out the photo, he draws it in charcoal on canvas. He rubs in transparent colour away from nature, he fixes the whole thing and leaves it to dry before a coal fire. He then puts in the final touches in thick paint, having always a whole series of works in an unfinished state to go on with.' Grant summarized Sickert's method as 'never work from nature'. In a letter to Miss Ffrangcon-Davies of the early 1930s, Sickert exclaimed, 'My box-photographer is superb. His name is Woodbine and he is one of the Herald's best more than best instantaneous light photographers.'

However, Sickert also used photography in a much more opportune way. He may well have liked photography to capture the unconscious energy in a person's pose; earlier he had expressed the need for speed in drawing – 'He has got to be drawn before the fizziness in his momentary mood has become still

and flat' – and it is clear that he strove to avoid his sitters becoming stale and fixed in their poses. The actress Gwen Ffrangcon-Davies recalled that she had expressed her reluctance to sit for her portrait. Sickert said, ' "Oh dear, it's quite unecessary. I don't want you to sit for me at all. I'd like to look through some of your photographs some time." So I took along a lot of my photographs … rather sort of the studio ones, and he said "Oh no, no, none of those at all, I wouldn't have anything to say to those". And then he suddenly picked up a snapshot which Bertram Park had taken of a play that I was doing – it was *Edward II* and I was Queen Isabella. Bertram Park had gone around with a little sort of camera, you know, just snap-shotting things. So he had … an impression of immediacy; it wasn't a posed photograph. And so he said, "That'll do …"'. Sickert might either use a photographer to pick up a sudden effect that he noted, or might alight upon press photography to provide him with the same stimulus. It is clear that he used photography, and perhaps especially the poor quality of press photographs, for its oddly dematerializing effects. Peggy Ashcroft noted, 'He would suddenly see something in a scene which to him, was very pictorial. He did a most curious picture of me as Lady Teazle, in which I am just a figure right on the footlights, complete distortion, and this was obviously what interested him. I'm almost a blank'. In a letter of 1932, Sickert proposed to Gwen Ffrangcon-Davies that his wife would take her to his studio where he would take 'a photograph in effective and rather mysterious light and shade'. 'She will then cut the head off the negative and have the body developed by one photographer, and the head by one in a different parish. I shall square it up myself and paint it in tones so *rapprochés* that people *will have to look twice* to see if there is a woman there at all.' In 1924 Sickert quoted Degas in support of the use of photography: 'On ne donne l'idée du vrai qu'avec le faux' – (One can only create an impression of the real with the false). It was for the 'strangely bowed and writhing shapes' which turn out to be 'more alive than many a figure which appears at first to be better done' that Sickert admired his future wife's paintings. Sickert used press cuttings for two portraits of George V, for a full-length portrait of King Edward VIII, for a double portrait of himself with Gwen Ffrangcon-Davies, for 'Peggy Ashcroft

in her Bathing Costume', and for several theatre portraits of actors and actresses on the stage. However, in comparison with his use of photographs for portraits, his use of press photography is restrained.

Photography was not new to Sickert. He had encountered it and its usefulness for artists at least as early as 1885, when Degas made him party to his own experiments with the camera. Degas sent some of Barnes' photographs to Sickert, and from as early as 1892 Sickert used photography to supply additional information for his portraiture. In the earlier part of his career however, Sickert cautioned its use. In an article in *The English Review* of 1912, he wrote, 'the camera like alcohol, or a cork jacket, may be an occasional servant to a draughtsman, which only he may use who can do without it'. By 1929 his attitude had shifted, and in a letter to *The Times* of 1929 he quoted an old music-hall song:

Some do it hopenly
Some on the sly, etc

to explain artists' use of photography. He continued, 'To forbid the artist the use of available documents, of which the photograph is the most valuable, is to deny to a historian the study of contemporary shorthand reports. The facts remain at the disposition of the artist'.

Sickert's use of engravings has a certain amount in common with his use of photographs. Both are black and white images to which he supplies colour. The engravings exist, however, as pictures already composed with perspectival depth in their own right. The challenge then to supply them with atmospheric colour, and enhance the spatial depth is one which Sickert meets, but to which he does not necessarily submit. His idiosyncratic solution to the coloration of the paintings he did from engravings is what makes them so arresting. What the engravings do not share with the photographs is their associative quality. They are further evidence of Sickert's interest in the Victorian. The engravings he chose to use for his series of 'Echoes' are by the nineteenth-century illustrators that he so much admired, some of whom he had also known: Francesco Sargent, Kenny Meadows, Adelaide Claxton, Georgie Bowers and John Gilbert. He found their work in the pages of old illustrated magazines, squaring it up just as he did the photographs. The 'Echoes' which he painted from

these engravings from 1927 and through the 1930s were very popular with his galleries and sold well. To his critics however they were a sign of his decline. Clive Bell considered that Sickert took his art seriously, but 'Not quite seriously towards the end maybe, when he took to making those comic transcriptions of Victorian illustrations. That was Sickert playing the fool'. In 1961, a former Director of the Tate, Sir John Rothenstein, judged that from 1914 Sickert's 'powers began ... to wane. For a painter to lose so completely his sense of judgement is a rare occurrence...'. Sickert was not secretive about his use of engravings, and indeed considered them a vital teaching aid. When teaching in Bath he took along portfolios of lithographs by Daumier and Gavarni, and a pupil, Lord Methuen, remembered that 'he gave us Victorian lithographs, engravings and so on to square up and copy on to a canvas, and then put them to what colours we thought'. Similarly, he advised Quentin Bell, 'You look through old copies of the *Illustrated London News*, or *Punch*, or better still some paper like *Judy*, something the bloody critics will never have heard of, find an engraving that you like, square it up, paint it in monochrome using white and ultramarine and then let it dry for two or three weeks. When it's quite hard, take an old silk handkerchief ... then take some linseed oil and rub down the picture until the surface is quite smooth. Then, using a very restricted palette, you paint the thing, but swiftly with rare and discreet touches, like a girl using lipstick'.

31. *Belvedere, Bath* c.1917
Oil on canvas
710 x 710
N05087

This is a view of Beechen Cliff from the Belvedere, Bath, and dates from the period which Sickert spent in Bath during the First World War. Another painting of the same view by Sickert is entitled 'Entry Hill, Bath', and the Victoria Art Gallery in Bath own a version entitled 'View of Beechen Cliff from Belvedere, Bath'. At least six studies of this view are known; two are in the British Museum and another in the Central Reference Library of Islington. The Belvedere was one of the motifs from Sickert's Bath repertoire which included Lansdown Crescent, Camden Crescent, and most importantly, Pulteney

Catalogue 31

Bridge. Here, as in Venice and Dieppe, he had a limited range of subjects, painting a few scenes over and over again. Most of these paintings date from 1916-18, but some were doubtless further versions painted at a later date. The townscape paintings which Sickert executed at Bath represent the perfecting of the new techniques which he had been developing through the war years. By 1913-14 Sickert had come to hate the 'greasiness' of thick oil paint, but did not find thinned down paint any more satisfactory. He sought a method which allowed one to work on the canvas at length without the paint becoming thick, dark and messy.

In a letter of 1918 written from Bath, Sickert told Nina Hamnett, 'I have certainly solved the question of technique ... It is extraordinary how agreeable undiluted paint *scrubbed hard* over a coarse bone-dry *camaieu* ... becomes. It tells semi-transparent like a powder or a wash ...'. This was for the earlier tones, and Sickert enjoyed their combination and contrast with the later touches which became 'fatter and more opaque'.

The Georgian grandeur and spaciousness of Bath appear particularly suitable for the pastel tones, creamy underpainting and rough, dry surface associated with Sickert's new approach. 'Peint comme une porte' (painted as if it were a door) Sickert quipped, quoting Degas. He continued the analogy with 'To use the house-painter's expression, the ground "grins

through '', and we understand Helen Lessore when she remarked that Sickert 'attached a great importance to what I think he called the cooking side of painting'. The challenge of painting the architecture must also have suited his new painting methods, which took correction particularly well. Repainting became a means to an end.

Belvedere, Bath
Pencil, pen and ink
203 x 178
Islington Public Libraries

Belvedere, Bath
Watercolour, pen and crayon
257 x 222
Trustees of the British Museum

Belvedere, Bath
Squared drawing in crayon, ink and pink wash
235 x 228
Trustees of the British Museum *(the above two studies will only be on show until July 1989)*

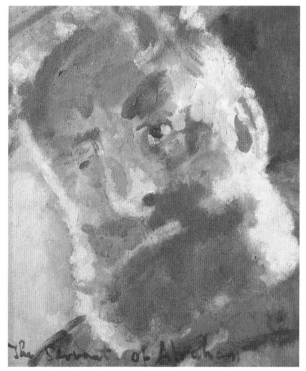

Catalogue 32

32. *The Servant of Abraham* 1929
Oil on canvas
610 x 508
T00259

This is the last of the series of Sickert's biblical self-portraits of the 1920s. Later representations of himself tended towards the everyday and were less evocatively grandiose. This portrait is based upon a photograph of Sickert taken by his wife, Thérèse Lessore, which was then squared up. A similar photograph was used for another self-portrait entitled 'Lazarus Breaks his Fast', and the third in this series, 'The Raising of Lazarus' derives from a staged photograph featuring himself and Cicely Hey. According to Mrs Helen Lessore, the Tate painting was conceived as if it were part of a large mural decoration, and the artist deliberately used a broad technique to show how he would have worked on such a project. This is in line with Sickert's opinion that 'We cannot well have pictures on a large-scale nowadays, but we can have small fragments of pictures on a colossal scale'. Although the title of this picture fits into the 'patriarchal' biblical line of the three portraits, this is not a portrait of the patriarch, but of an apparently anonymous servant. The fact that no particular servant is attached to the story of Abraham further emphasizes the odd vacuousness of the position.

Two photographs of Sickert (one reproduced above)
From the collection of Miss Catherine Powell,
Courtauld Institute of Art

41

33. *The Front at Hove (Turpe senex miles turpe senilis amor)* 1930
Oil on canvas
635 x 762
N04651

This is a view of Adelaide Crescent with Brunswick Terrace and The Lawns in the foreground. Sickert retained his studio in nearby Kemp Town (at 5 Lewes Crescent) until 1931. Sickert features in this painting as the old man on the bench, and this suggests that the whole scene may be taken from a photograph. The woman on the bench may be his wife, Thérèse Lessore. The quotation in the title comes from Ovid's *Amores* I, ix and means 'An old soldier is an ugly sight and so is foolish love'.

34. *The Idyll* c.1931
Oil on canvas
686 x 724
Ferens Art Gallery: Hull City Museums and Art Galleries

This painting from the 'Echoes' series derives from John Gilbert's engraving, 'An Embarrassing Moment'. It was exhibited in the Beaux Arts Gallery in 1932, and purchased there in May by the Ferens Art Gallery. It was illustrated alongside its source in the *Illustrated London News* of 9 April 1932.

John Gilbert, *An Embarrassing Moment,* as reproduced in the *Illustrated London News*

Catalogue 34

Catalogue 35

35. *Summer Lightning* c.1931
Oil on canvas
627 x 723
Walker Art Gallery
(see illustration on previous page)

'Summer Lightning' is drawn from Gilbert's engraving 'The Unexpected Rencontre' and this pair was illustrated in the same edition of the *Illustrated London News* as 'The Idyll'. In a letter of 12 December 1932 Sickert wrote, 'Liverpool has bought the "summer lightning" picture (the G.O.M's rendez-vous with Mrs. Langtry) for several hundreds I forget how many'. Sickert's squaring-up is still quite visible under the paint.

Photographs from *Illustrated London News* 9 April 1932.

John Gilbert, *The Unexpected Rencontre,* as reproduced in the *Illustrated London News*

Catalogue 36

Left: Daily Sketch, 23 May 1932.
Source for Catalogue 36

36. *Miss Earhart's Arrival* 1932
Oil on canvas
714 x 1832
T03360

Amelia Earhart was the first woman to fly solo across the Atlantic. She landed in Ireland on 21 May 1932, and the following day was flown to Blackpool, and thence to Hanworth Air Park near London, where she was greeted by large crowds. Sickert based his painting on a photograph published on the front page of the *Daily Sketch* of 23 May 1932, and it was shown in the Beaux Arts gallery only seven days later. The photograph published in the *Daily Sketch* on this occasion reveals that the squaring up was still visible in Sickert's painting at this date. This had been re-moved at some point before 1933, when it was repro-duced in the Carnegie International Exhibition cata-logue. Although Sickert must have worked a good deal on this painting over a very short period of time, Mrs Helen Lessore felt certain that her sister-in-law, Sickert's third wife, did not work on this painting, although it was often her practice to assist him in later years. As Jacques-Emile Blanche recalled from 1939, 'Did he not say that, lying on his bed, he *dictated* to Mrs Sickert the squaring up of the canvas and told her what colours to apply?'

Photographs from the *Daily Sketch*, 23 May 1932 and 31 May 1932

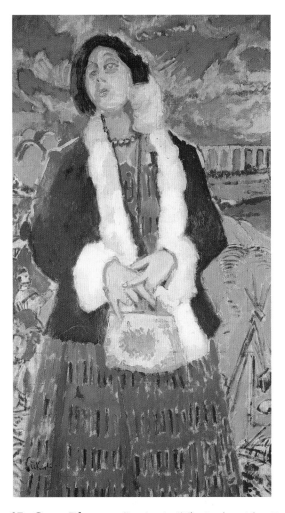

37. *Gwen Ffrangcon-Davies in 'The Lady with a Lamp'* c.1932-34
Oil on canvas
1222 x 685
Private Collection

Sickert painted four portraits of Miss Ffrangcon-Davies in stage roles; thrice in Marlowe's *Edward II*, and this picture of her playing Florence Nightingale in *The Lady with a Lamp* which was on tour in the autumn of 1929. This painting, like the others, was done from a photograph, and Sickert probably never saw the play. It is notable that after the 1920s Sickert shifted from painting the architecture of the theatres, to painting the performers. Sickert told Gwen Ffrangcon-Davies in a letter of 12 December 1932 that 'The Lady with the Lamp is stood out on a balcony to dry facing Miss Buss or Miss Beale's girls' school hockey field where it appears to interest that generation'.

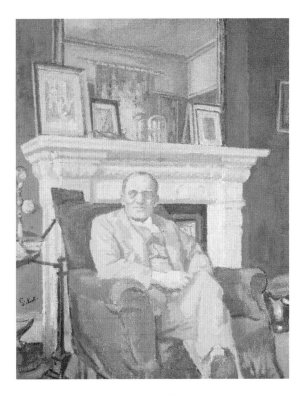

38. *Sir Alec Martin, KBE* 1935
Oil on canvas
1397 x 1079
T00221

Sir Alec Martin was Sickert's sole executor, and until 1958 Chairman of the auctioneers Christie, Manson and Woods. In the early 1930s he came to Sickert's aid, and set up a subscription fund to provide financial support. In 1935 he commissioned and paid for these portraits of himself, his wife and his youngest son. In a letter of 30 December 1958, Sir Alec wrote, 'The Portraits were done when Sickert lived near me at St Peter's-in-Thanet they were not done from photographs. The one of my son was started in the garden of our house Marandellas at Kingsgate and finished in Sickert's studio. The Portraits of my wife and myself were painted in Sickert's house at St Peter's.' In answer to another prompting from the Tate curator engaged in cataloguing the pictures, Sir Alec replied, 'When I wrote you recently... I was unaware that any photographs had been taken for our Portraits, certainly none was taken of me to my knowledge, but in talking to my wife she says that she remembers Thérèse Lessore (Mrs Sickert) did take a snap of her one day as she entered Sickert's painting room, and she says that Mrs Sickert also took a snap of Claude in our garden at Marandellas. These may have been used as the Foundation of their Portraits... I cannot say that a snap wasn't taken of me there but not to my knowledge'. In a third letter dated 6 January 1959 Sir Alec wrote, 'All the three Portraits were painted at Hauteville'. In view of the fact that the three Martin portraits are traditionally taken to be done in the main from photographs, and certainly look as if they were done from photographs, Sir Alec's remarks gain in significance. Although it transpired that his wife did remember photographs being taken of her and Claude, Sir Alec had no recollection of any photograph being taken of him. It clearly seemed to him that his portrait had been done from the sittings he gave, and he must thus have given up sufficient time to make this credible. Moreover, the photograph of Lady Martin must have showed her entering the room, and could not have been a direct source for the portrait. A small pencil sketch of Sir Alec Martin was recently sold at Christie's.

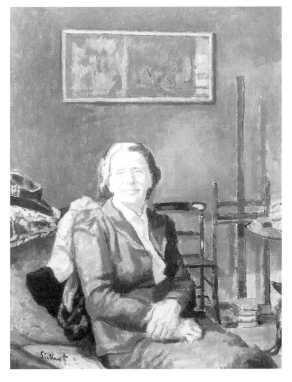

39. *Lady Martin* 1935
Oil on canvas
1397 x 1079
T00222

40. *Claude Phillip Martin* 1935
Oil on canvas
1270 x 1016
T00223

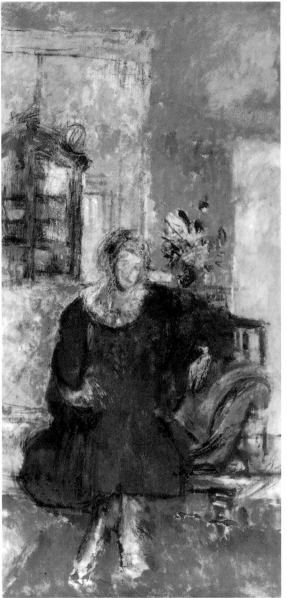

41. *Mrs Anna Knight* 1941–42
Oil on canvas
1524 x 762
N06142
This portrait was done at Mrs Knight's home in Bath from life, but Sickert had to abandon it because of illness. It may well be Sickert's last work.

MR. RICHARD SICKERT, an exhibition of whose paintings is being held at the Leicester Galleries, in his studio at Broadstairs. He declined an opportunity to tidy the room before the photograph was taken, insisting things should remain as they were. The private view of the exhibition, which represents Mr. Sickert's work during the last two years, takes place to-day.

Photograph of Sickert and Thérèse Lessore reproduced in the
Daily Telegraph 24 February 1938 and *The Sketch* 2 March 1938

SELECT BIBLIOGRAPHY

Arts Council 1981-82 *Late Sickert. Paintings 1927-1942*

Peter Bailey *Leisure and Class in Victorian England*, London, 1978

Wendy Baron *Sickert*, London, 1973

Wendy Baron *The Camden Town Group*, London, 1979

BBC Transmission 10 February 1961 with Basil Taylor, Peggy Ashcroft, Gwen Ffrangcon-Davies, Clifford Ellis, Cicely Hey, Helen Lessore, Sir Alec Martin, Lord Methuen, Hubert Wellington

BBC Transmissions with Helen Lessore 5 November 1966, Cicely Hey 14 November 1966, Clifford Ellis 19 November 1966

Max Beerbohm *More*, London, 1899

Clive Bell *Old Friends. Personal Recollections*, London, 1956

Anthony Bertram *Sickert*, London and New York, 1955

Jacques-Emile Blanche *Dieppe*, Paris, 1927

Jacques-Emile Blanche *Portraits of a Lifetime. The Late Victorian Era. The Edwardian Pageant. 1870-1914*, London, 1937

Jacques-Emile Blanche *More Portraits of a Lifetime 1918-1938*, London, 1939

Lillian Browse *Sickert*, London, 1943

Lillian Browse *Sickert*, London, 1960

Robert Emmons *The Life and Opinions of Walter Richard Sickert*, London, 1941

Charles Harris *Islington*, 1974

Marjorie Lilly *Sickert, The Painter and his Circle*, London, 1971

Albert Ludovici *An Artist's Life*, London, 1926

R Mander & J Mitchenson *British Music Hall*, London, 1965

George Moore *Conversations in Ebury Street*, London, 1930

Richard Morphet 'The Modernity of Late Sickert' *Studio International*, vol 190, July-August 1975 pp 35-8

Sir John Rothenstein *Sickert*, London, 1961

Harold Scott *The Early Doors*, London, 1946

Richard Shone 'Duncan Grant on a Sickert Lecture' *Burlington Magazine* November 1981

W R Sickert collection in Islington Central Library

Osbert Sitwell ed *A Free House!: The writings of Walter Richard Sickert,* London, 1947.

W H Stephenson *Sickert: the Man and his Art: Random Reminiscences*, Southport, 1940

Denys Sutton *Walter Sickert*, London, 1976

Tate Archives: letters to Mr Angus, Mrs Schweder and Gwen Ffrangcon-Davies

Virginia Woolf *Walter Sickert: a Conversation*, London, 1934

Pieter Zwart *Islington*, London, 1973